Lucy Willis

Travels with Watercolour

Lucy Willis 1995

Lucy Willis

Travels with Watercolour

Lucy Willis with Robin Capon

B T Batsford

For Tony

I dedicate this book to Tony Anderson who, since 1976, has either accompanied me
on my travels or enabled me to go away painting by taking care of our children.

Acknowledgements

Thank you to Robin Capon, whose patient hard work has made this book possible;
to Sally Bulgin at *The Artist* magazine and Liz Drake at Spencer Scott Travel for
promoting and organizing my group painting trips; to all the people in far-flung
places who have helped me and often been kind enough to sit for me;
to Jill and John Hutchings at Curwen for marketing my work.

www.lucywillis.com

Page 1: The Silent House, Greece 42 × 58 cm (16$^{1}/_{2}$ × 22$^{3}/_{4}$ in)
Page 2: The Coconut Seller, Zanzibar 43 × 32 cm (17 × 12$^{1}/_{2}$ in)

Lucy Willis is represented by the Curwen Gallery, 4 Windmill Street, London W1T 2HZ
Tel: 020 7636 1459; www.curwengallery.com

First published 2003
Images © Lucy Willis 2003
Text © Lucy Willis and Robin Capon 2003
The right of Lucy Willis and Robin Capon to be identified as Authors of this work has been asserted to them in
accordance with the Copyright, Designs and Patents Act 1988.

ISBN 0 7134 8826 3
A CIP record for this book is available from the British Library.

Designed by Zeta Jones

Printed in China

for the publishers
B T Batsford
64 Brewery Road
London N7 9NT
www.batsford.com
A member of Chrysalis Books plc

Distributed in the United States and Canada by
Sterling Publishing Co., 387 Park Avenue South, New York, NY 10016, USA

Contents

Introduction

In 1987 I received a phone call out of the
blue. Would I like a commission to go to
Portugal and paint for two weeks in the
quintas and vineyards of the Douro valley?
To travel and paint – my two favourite
things! I relished the opportunity to see a part
of the world I didn't know and without
hesitation I went, returning home with a large
portfolio of watercolours: everything from
the Portuguese architecture and landscape to
people and the ever-changing river.

That same year I was asked to paint
watercolours in Guernsey for a booklet on
the island (I came across the booklet years
later in a house in Budapest!). I was now
getting the hang of packing up my
equipment, going off to an unknown place
and filling each day with continuous
painting sessions so I could capture as many
impressions as possible in the given time.

Then in 1989 I had another unexpected
invitation: would I take a group of painters
abroad? The destination could be anywhere
I chose in the world – irresistible! There
were a few false starts in finding a suitable
place (war broke out in Kashmir then civil
unrest in Nepal) but when we finally made it
to Yemen it turned out to be the most
inspiring and extraordinary place. This was
the beginning of a fruitful and long-running

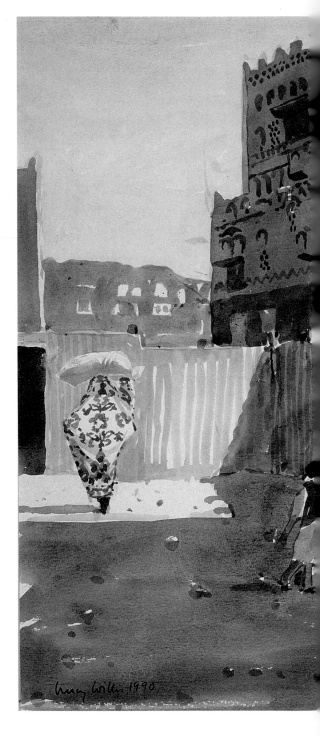

Right: **Women of Rada'a,
Yemen** *43 × 64 cm (17 × 25in).*

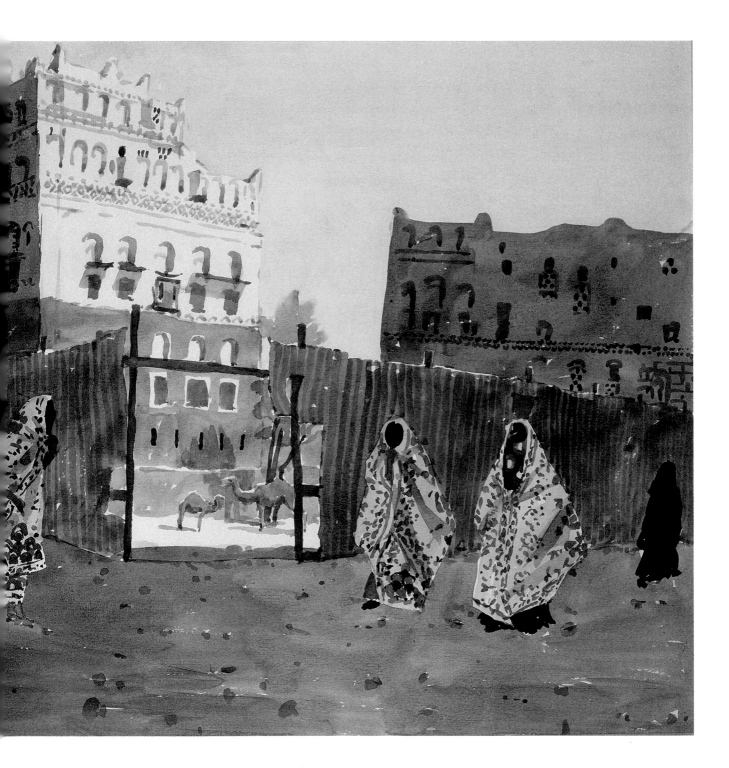

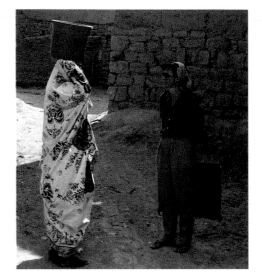

Above: **Lucy Willis talking to a woman from Rada'a, Yemen, 1990.** *Photo by Tilly Willis.*

Opposite page: **Forgotten Palace, Udaipur, India** *41 × 30 cm (16 × 12 in).*

Since I was a teenager I've always carried a sketchbook – and this discipline seemed to lead quite logically to painting abroad. Making a visual record of places and people has become second nature to me. Although I don't feel I have to travel in order to find inspiration – much of the time I work quietly in my studio at home – travelling has become part of my life. I love it for its own sake and the fact that I can paint along the way is an added bonus and a means of getting to the very heart of a place.

Most of my watercolours are painted on the spot. It is a great medium for the travelling artist: compact and versatile. It suits both the immediate, simple reference study and the more resolved response to a subject, whether from direct observation or filtered through memory. In choosing the different paintings to illustrate this book, along with the accompanying captions, text and the insights of other artists, my aim has been to provide information and ideas that could be helpful when you are planning your own painting trips. The final section provides ideas to help you make the most of your experiences once you return. I am conscious of the fact that my way of painting is only one way, a watercolour technique that I taught myself. But I am hopeful that it will provide a useful basis from which you can develop a confident approach to recording your own travels.

collaboration with *The Artist* magazine and in the past 13 years I have also taken groups to paint in India, Zanzibar, Egypt and Morocco as well as France, Spain and Crete.

Travel is something I have always enjoyed. As an art student I travelled around Europe and North America, before settling in Greece for three years after I had left art school. I never tire of painting in Europe (I return to Greece regularly) and now, with a family connection in Senegal, I go there too. I like to see how other people live. I like to discover something about their culture, language and general way of life. Inevitably I am sometimes appalled by what I find; the poverty and inequality in some places, for example. But as an artist I like to take a positive view. There is always so much to enjoy visually and I try to record and communicate some of these things.

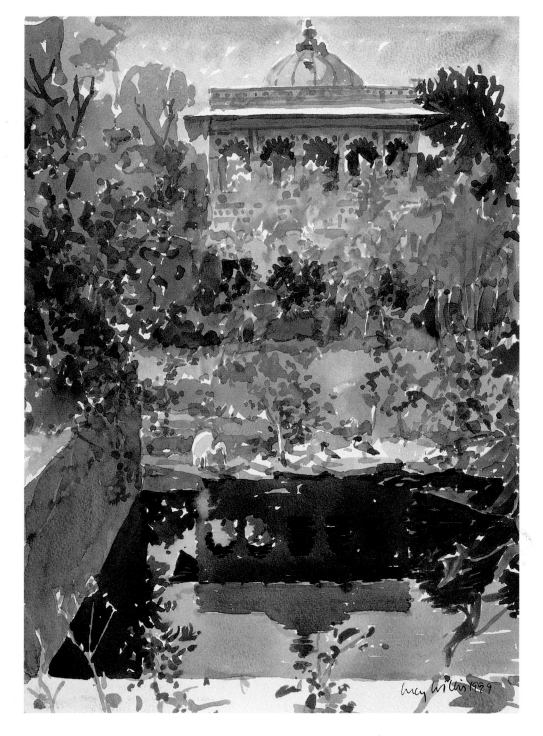

Chapter 1
Painting on Location

Practical Considerations

'His main priorities when painting out of doors were: (1) **Shelter from the wind**; (2) **Proximity to a lavatory**; (3) **Shade from the sun**; (4) **Protection from children**; (5) **Subject**.'

Philip Connard, discussing his recollections of watercolourist Philip Wilson Steer, with whom he travelled in England in 1932. From *Life, Work and Setting of Philip Wilson Steer*, D S MacColl, Faber and Faber, London, 1945

Travel is inspirational. It brings us into contact with unfamiliar, interesting sights and ideas, and it increases the scope of possible subjects to sketch and paint. Painting in a new location is always an intense experience, because we have a sharper awareness of everything around us: the mood and atmosphere and often the activity of the place envelops us. This helps generate a fresh energy and enthusiasm. Because we are actually there, witnessing everything that's going on and having direct access to the subject, we are often inspired to paint with greater insight and vigour.

Distant, exotic places have an appeal, of course. But you don't necessarily have to venture that far to find interesting things to paint. Whether you travel abroad or to different parts of your own country, painting on your travels is always exciting, challenging and rewarding.

Naturally, painting skills are important, and for watercolours it is especially the kind of skills and techniques that enable you to work in a spontaneous and confident way that are most important. But success with painting on location also depends on various practical considerations. These include planning exactly what you will need in the way of equipment and materials, and being aware of the differences in climate and culture. If you are going abroad some preliminary research about the country you are planning to visit is always helpful, for you will enjoy your painting trip all the more if you are well prepared.

Why Watercolour?

There are a number of reasons why watercolour is a good choice for the travelling painter. For one thing, it requires little in the way of essential materials and equipment. Indeed, to paint a watercolour all you need is a sheet of paper, one or two brushes, a paintbox and some water. Moreover, these items are lightweight and compact, so they are ideal for painting on location, when you might have to reach your chosen subject by walking, taking a

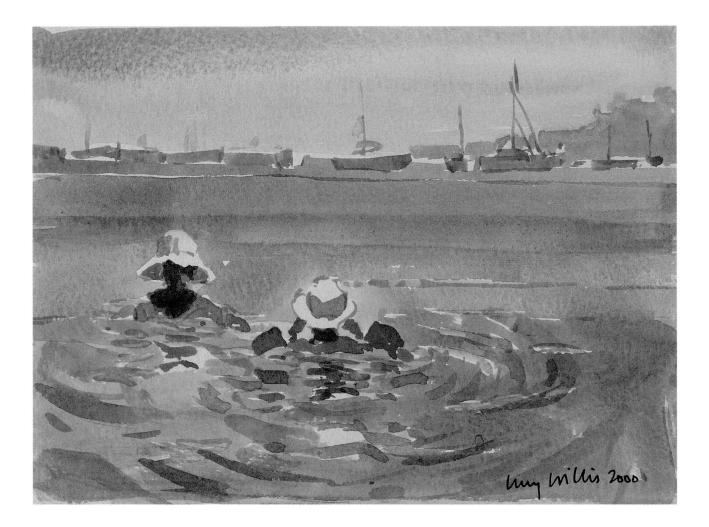

train, or even riding a camel – as I did when setting out to paint Saint Simeon's Monastery in the dunes above Aswan, Egypt, illustrated on page 24. In fact, for small studies made in something the size of an A5 watercolour pad (148 × 210 mm or 5⁷⁄₈ × 8¹⁄₄ in), all the essential equipment could be carried in your jacket pocket.

I began using watercolour on my painting trips for this reason, because I thought it would overcome the various practical difficulties I had experienced with oil paints. On my first painting trip abroad as a

student, to Greece, I took a backpack full of oil paints, boards, brushes and so on. The main problem, apart from the weight and bulkiness of the equipment, was that the paintings took time to dry. It was very difficult to transport them without the surface of the paint getting damaged. So, on subsequent trips to Europe and other parts of the world, I chose to work in watercolour, which by that time had become a much more familiar, and therefore pleasurable, medium for me.

Watercolour, of course, is quick-drying.

*Above: **Bathing at Finika, Greece** 14 × 19 cm (5¹⁄₂ × 7¹⁄₂ in). I usually take my basic watercolour equipment to the beach with me so that if something catches my eye, like these bathers in their sunhats, I am ready for it.*

This is a big advantage when time is limited and you need to pack up your things and move to another location. So it is convenient, but equally it offers its own unique qualities and characteristics as a painting medium. I relish the fact that watercolour enables me to interpret what I see quickly and spontaneously yet with the full range of colour and tone.

Watercolour is an extraordinary medium. By mixing just a tiny amount of pigment with some water you can make enough paint to cover a whole sheet of paper. In that sense it is a very efficient means of painting, yet equally it is an extremely effective one, for watercolour can be applied and handled in many different ways to create a wide variety of results. If you wish, you can achieve a richness of texture and a depth of tone in your paintings that will rival those made in any other medium. Those people who believe that watercolour is a delicate, wishy-washy medium are mistaken. It is true that achieving sufficient contrasts of tone in watercolour painting can be a difficult aspect for beginners to master. With time and patience, though, most artists learn ways of handling the medium to give the strength and impact of tones they require.

A notable characteristic of watercolour is its unpredictability. Eventually you learn to control the results or exploit the surprises, but to start with you never quite know how a wash will settle and dry on the paper or what will happen when you allow one colour to bleed into another. For me this was part of the challenge and enjoyment of learning to work in watercolour, and I still like the element of surprise and discovery that inevitably occurs in every painting. This applies to the painting process in any medium, but it is a much more obvious feature in watercolour, and it can prove a difficult quality to deal with, especially for those new to the medium. My advice is to persevere. Once you have built up an understanding of watercolour and how it behaves, you will be able to paint to its strengths, and you will learn to accommodate the often interesting and enlivening effects that its unpredictable nature creates.

Watercolour can be a wonderfully fresh and direct medium to use. Applied to white paper its colours are translucent and glowing, and by working with just one or two simple overlaid washes (areas of heavily diluted colour) it is possible to create an impression of a scene, capturing mood and atmosphere and quickly expressing what you feel is significant about your subject. The important thing to remember is not to overwork the paint, and so avoid the danger of muddy colours and dull, heavy passages within the painting.

For me a successful travel painting is one that conveys the sense of wonder I experienced when I was there. Like a diary, the best paintings encapsulate many things: thoughts and feelings as well as images.

Equipment

'I knew I would have to take everything – film, paper, ink, watercolours – with me because I didn't know what I could buy in China … My drawings got more and more Chinese: I started using brushes and flicking ink. I used all kinds of media … One problem was that the trip was organized so we were always moving … so I realized I had to devise a method of drawing quickly or from memory.'

David Hockney on travelling in China, from *That's The Way I See It*, David Hockney, Thames & Hudson, London 1999.

Estimating the quantity of paper and other materials you will need for a painting trip is never easy, although from the experience of the first few trips you should be able to gauge what constitutes a realistic amount. The tendency is to take too much, but it is better to take whatever you consider will be useful, rather than rely on buying items on location. In many countries art materials are not always readily available, and they can be very expensive.

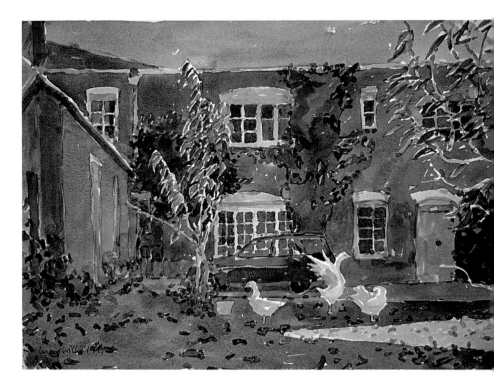

The quality of the materials that I choose for location painting is exactly the same as those used for my studio work. No matter where you are painting it is always more satisfying to use artists' quality paints and the best equipment that you can afford. Good materials do make a difference to the way that you can handle paint and to the clarity and impact of the completed picture.

For working outside I carry a supply of paper in an A2-size portfolio (420 × 594 mm or 16¹/₂ × 23³/₈ in) and the remaining equipment in an old rucksack, chosen deliberately because it is a less tempting item to steal. The rucksack contains my camera,

*Above: **Autumn Cherry in Sunlight, England** 30 × 43 cm (12 × 17 in). The geese in this painting appeared before I had completed the background so I included them before they wandered off again. I left their shapes very pale, but added more definition by carefully painting the darker tone behind them.*

a small folding stool, a blow-up rubber cushion, a sketchbook and various sketching materials (black pens, coloured pencils, wax crayons), a watercolour paintbox and one or two tubes of gouache (opaque watercolour, consisting of pure pigment in a gum binder plus precipitate chalk or blanc fixe), brushes, a plastic container for water, and a hat to keep the sun out of my eyes and protect the paper from glare. Usually I work sitting down, with the portfolio acting as a support on which to rest the paper.

Below: **Miriam's Sister, Senegal, Africa** *32 × 29 cm (12¹/₂ × 11¹/₂ in). Here I used strong black watercolour in the background for the darkest areas as well as a mixture of crayon and charcoal pencil in other parts of the picture.*

Paints

When travelling around I like to work with quite a limited range of colours, just as I do at home. I find the three colours I use most are cerulean blue, yellow ochre and Winsor violet. These provide me with a versatile basic range when mixed, which I can supplement with small amounts of other colours when required.

My paintbox contains about a dozen colours in all and I sometimes carry a few others, which may include one or two designers' gouache colours that I think I will need in order to create the intensity or accuracy of certain very bright colours. I take Rose Tyrien for bougainvillea flowers, for example, and cobalt turquoise for Mediterranean shutters. I check the paints each day before going out and if any of the pans are in need of refilling I top them up from my stock of tube paints. My basic palette is cadmium yellow, lemon yellow, yellow ochre, sap green, cadmium red, alizarin crimson, cobalt blue, cerulean blue and Winsor violet, and I supplement this with Prussian blue, ultramarine blue, cobalt turquoise and black.

While I occasionally use black I never think of it as a means of creating shadows or darkening colours, where it usually has a deadening effect. I use black as black, as in the door in *Miriam's Sister* (left), rather than for mixing. For the darks I mix

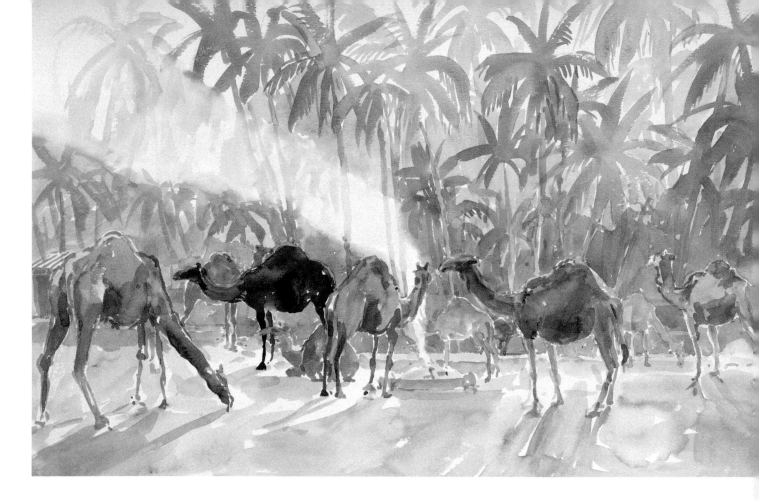

Prussian blue or ultramarine with cadmium red and cadmium yellow. Similarly, I use cerulean blue mixed with yellow ochre and a little Winsor violet to make a useful range of greys. You will notice too that I do not include any kind of white in my palette. I prefer to leave the white of the paper for the lightest areas, although I sometimes use a little touch of designers' white gouache for making corrections in the studio.

You may prefer a different choice of colours, but my recommendation would be a palette consisting of two each of the three primary colours (red, yellow and blue) plus a green and a purple. This selection should enable you to mix any colour you need. As I have said, it is advisable to buy artists' quality paints, which contain better

pigments and are more permanent. These are available in pans, half pans and tube colours and, of course, in a variety of brands. I prefer Daler-Rowney and Winsor & Newton watercolour paints, basing my choice on the qualities of individual colours. You do not have to stick to one brand of paints – good-quality watercolours are compatible across different makes.

Brushes

There is an immense range of brushes available. These vary from inexpensive synthetic-hair brushes to the finest Kolinsky sables, and from flats and fan brushes to mops and riggers (a brush with a long, thin head used to paint fine lines and details). But here again, your work will not be

Above: **Camels Round a Smoking Fire, Salalah, Oman** *43 × 64 cm (17 × 25 in). I often use just one large brush. Providing it has a reasonable point I can use it throughout the painting for finer marks, like the camels' legs, as well as the broader ones, such as some of the palm fronds.*

inhibited if you keep things to a minimum. One or two wisely chosen brushes will give you all the versatility of approach and technique that you need. The main characteristic of a good watercolour brush is that it can hold a large quantity of paint and release as much or as little as you wish. The hair of the brush should be fine yet resilient and capable of tapering to a point (though not too sharp a point) so that details are possible, even with the largest brush.

You seldom need more than two or three brushes and quite often just a single brush is sufficient. With the right brush you can achieve an extraordinary variety of strokes, from broad washes to fine lines. My preference is a size 14 round sable, which I like to be slightly blunt if possible so that it doesn't leave 'flick' marks. In fact I sometimes snip the tip off, although I wouldn't recommend that everyone tries this on their expensive brushes! Inevitably after a while a brush will become too worn for fine work, but it will still have its uses for larger washes and other techniques.

Sable brushes hold their shape well and are springy and sensitive, which means that they respond to the slightest variation of pressure, allowing a good deal of control over the marks made. A further advantage is that, with several flicks of the wrist away on to the ground (though be careful where you're pointing), a sable brush will shed all

the water or paint it is holding and be dry enough to dip into another colour. But whether you choose sable or synthetic-hair brushes, they are worth looking after. Brushes can easily be damaged while they are being carried around, so pack them carefully and wrap them in a piece of soft cloth. When you have finished a painting, rinse your brushes in some clean water, flick them a few times to remove any surplus moisture, and reshape the tip by gently dragging the hairs between your thumb and forefinger.

Paper

Here again there is a wide choice. Watercolour papers can be handmade, mould-made or machine-made and they are produced in three types of surface texture: hot-pressed [HP]; cold-pressed [Not]; and Rough. Hot-pressed papers have a smooth, fairly firm surface, making them ideal for controlled, detailed work though not very suitable for expressive washes. Not papers are slightly textured and make a good general-purpose paper, and Rough papers, as the name implies, have an obvious tooth or surface texture. You can buy paper in sheets, blocks or pads, and there are various sizes and weights to choose from.

The bulk of watercolour paper is produced as Imperial, 560 × 760 mm (22 × 30 in) sheets, which is a standard international size, although larger and

*Opposite page: **Tall House, Saumur, France** 31 × 20 cm (12¹/₄ × 8 in). I carry a selection of paper in my portfolio, cut to various shapes and sizes. Then, if I come across a subject such as this, charming for its unusual proportions, I have a suitable sheet of paper to hand.*

smaller sheets are also available, as well as rolls. The weight of paper is stated in grams per square metre (gsm) or pounds per ream (500 sheets). Thus, a 150 gsm/72 lb paper is a lightweight, thin paper, whereas a 600 gsm/300 lb paper is much thicker and heavier. Most paper is white or off-white, although you can also buy tinted papers, such as tinted Bockingford. The best papers are rag papers, made from 100 per cent cotton. All the well-known brands are acid-free, so they will not discolour with age.

It is always worth experimenting with a number of different papers to see how they respond to your working methods. I use 300 gsm/140 lb Bockingford Rough, Saunders Waterford Rough, and handmade papers such as Two Rivers 300 gsm Rough, which I have recently discovered. This is made in a small mill near my home in the west of England and it is one of several weights and surfaces produced by this company that are ideal for watercolour. I like these heavier papers because they will take repeated washes without distorting or buckling too much. I never stretch the paper. If I apply a large area of wash and the paper wrinkles, I wait until it is touch dry and then place it under a drawing board or similar weight to flatten it.

I normally buy a quantity of paper in Imperial sheets, which I then cut to the sizes

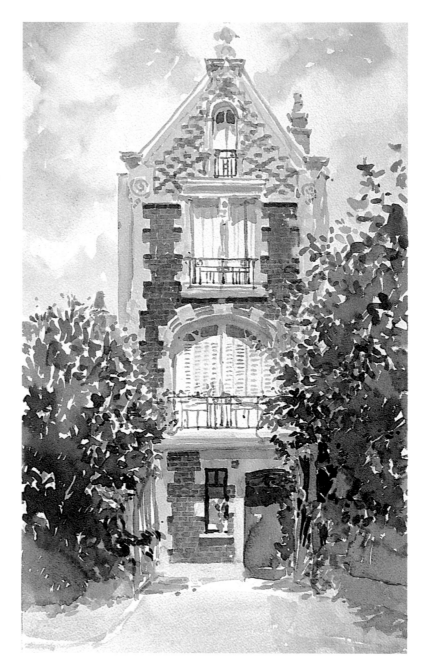

I require. For a painting trip I estimate that I need three large sheets of paper per day. This allows for a few mistakes! Although good-quality paper is quite expensive, you should try not to allow that to inhibit the way you use it.

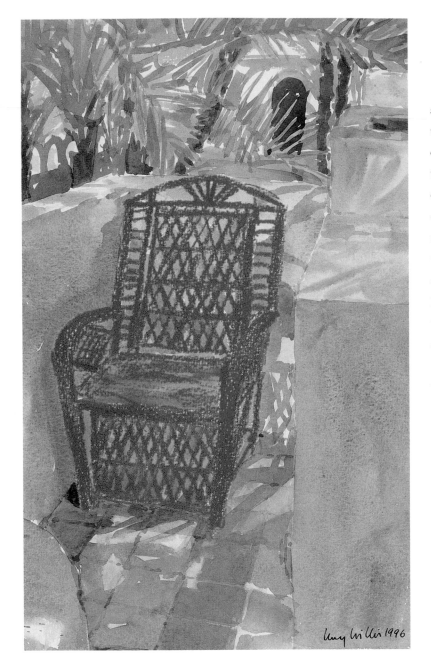

and handling characteristics. The use of these mediums is a matter for individual choice: personally I never use them. Rather than applying masking fluid I prefer to paint carefully around areas of white. However, I do occasionally use wax resist, either in the form of a coloured wax crayon, as in *Yellow Chair at the Habu Hotel* (left), or a candle stub, as in *The Red Bicycle* (page 42). Having drawn in any filigree areas with wax you can then paint over them with impunity and the pattern will emerge.

I would advise carrying a sketchbook in which to jot down ideas in pen or pencil and make little figure studies and so on, and that you consider taking a camera. Photographs are useful for those subjects that you don't have time to paint or sketch on location. You can use them as additional reference material or starting points for paintings made in the studio when you return home.

Above: **Yellow Chair at the Habu Hotel, Luxor, Egypt**
43 × 32 cm (17 × 12 ¹/₂ in).
Occasionally I use a wax crayon to simplify the painting process. I used a yellow one here to avoid the painstaking job of painting the turquoise spaces seen through the chair. Once the chair was drawn in wax I could wash straight over it with turquoise.

Other Materials

You may wish to use masking fluid to protect the white areas in your paintings from any subsequent colour washes, and you could also add various watercolour mediums to the paint to enhance its flow

Different Countries and Cultures

'I live in London at times – then
comes a dull day – wet and wild –
murky – I shudder – I seize a
carpet bag – I pack in it a paintbox, a
sketching block, a dozen of Chinese
white, a shirt, a pocket handkerchief –
I rush downstairs into a Hansom –
Where to sir? – "To Egypt".'

From *Thoughts from Hercules Brabazon Brabazon*,
transcribed by Gertrude Jekyll, 1879

Sometimes it is possible to plan a trip
specifically to paint, on other occasions
painting may not be the principal reason
for travel and then one has to adopt an
opportunistic approach. If, for instance,
you are thinking of visiting a country with
the main intention of painting as often as
you can, then you will probably want to
choose somewhere that suits your
particular interests and strengths. The
subjects I enjoy most are architecture and
people. I look for places where there are
interesting urban or village scenes, with
buildings, trees, gardens and people. What
appeals to me, and what I aim to express in
my paintings, is the concept of people and
their culture.

On the other hand, for many years I
went with my children on beach holidays,

*Opposite page: **Fencing, Senegal**
15 × 21 cm (6 × 8¹/₄ in), pen
studies.*

*Below: **Old Turkish Quarter,
Hodeida, Yemen** 43 × 64 cm
(17 × 25 in). The way in which
people around the world built
their houses and how they live
never fails to interest me. I was
told that the advent of plastic
bags in Yemen created problems
because the roaming goats and
camels could no longer browse
freely on the rubbish as they had
in the past, resulting in scenes
such as this.*

lucy willis 1990

*Above: **Men talking, Albufeira, Portugal** 1986 20 × 25 cm (8 × 10 in). It was when my children were little, and I found myself having seaside holidays with them, that I discovered the potential of painting on the beach. This was one of the first direct, on-the-spot beach studies I attempted.*

can't paint here because it's not my kind of subject'.

People approach painting trips in different ways. For some it is important to plan the destination and itinerary carefully and do a good deal of research, while others rather like the idea that they are venturing into the unknown and that there will be the challenge of new subjects and painting situations. Also, there is the choice of whether you wish to travel and paint on your own, or whether you would prefer to be with someone else or part of a group. Many tour operators and holiday organizers advertise guided or tutored tours abroad.

and although to begin with this was not the type of subject that I would have chosen to paint. I did find it a surprisingly rich and worthwhile experience; figures, water, wet reflective sand. The more I looked, the more I saw, and the longer I spent there, the more interesting it became. The fact is, whether you actually choose your location or whether it is chosen for you, there are always exciting things to paint. Recognizing potential subjects is partly a matter of experience of course, but the more you look at and notice relationships of different shapes, colours, and lights and darks, the more adept you will become at finding good images. Wherever I go, I would never say 'I

I have led quite a number of groups on painting holidays to different parts of the world. In 1990, for example, I took my first group of painters to Yemen for ten days and then stayed on with my sister, who is also an artist, for another two and a half weeks to explore the country further and continue painting. The advantages of being in a group for the first part of the trip were numerous. We were provided with a Yemeni guide as well as an English tour manager to smooth the way. For most of us it was our first experience of an Arab country, and without the guide many of our questions about the people and culture, history, religion and daily practices would have gone unanswered.

In this context it is important to be sensitive to the fact that many countries have a culture and customs that are very different to our own. It is important to respect these. People in the cities you visit may have a more relaxed outlook, but in a remote village you might find that customs and suspicions are more pronounced, especially when it comes to matters such as dress code and the use of cameras. In some countries, for instance, it may be considered offensive for women to be seen in shorts or with nothing covering their head, or it may

Below left: **Yellow House among the Trees, Senegal, Africa** *38 × 56 cm (15 × 22 in). However blisteringly hot the country you visit, there is usually a quiet garden to provide shade for painting, which is so important when you don't want your watercolour to dry too fast on the paper.*

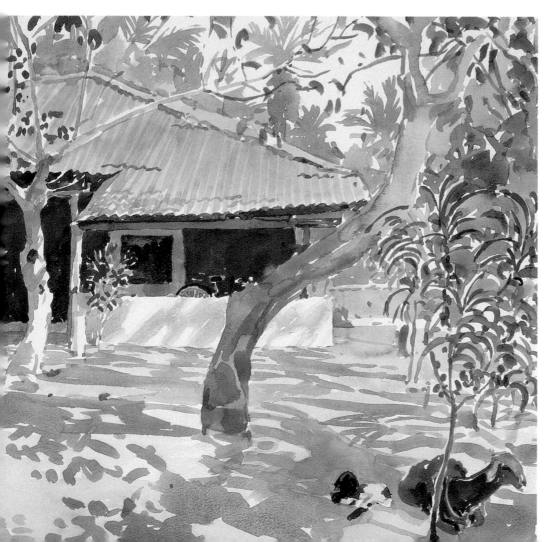

be equally offensive to photograph people. I have found that few object if you draw or paint them, especially if you ask first, because they can see exactly what you are doing – indeed, they may be willing to model for you – but photographs can be regarded with suspicion.

Being open, friendly and patient, as well as willing to communicate with people, is invariably the best approach. If I want to peep over someone's wall to paint their garden, or sit in the street and paint their house, whenever possible I ask the owner's

permission. Generally people are friendly and cooperative. I remember that in Yemen, for example, our painting group was shown great hospitality. On one occasion a member of the group was beckoned off the street in mid-brushstroke to have a cup of tea, and when we were in the countryside we were brought handfuls of tiny apples and apricots to keep us going.

Weather and Light

'Summer was Renoir's season; unlike Monet he could not interest himself in any other time of year. Why, he once asked, paint snow, the leprosy of nature?'

From *Renoir*, William Gaunt, Phaidon Press, London, 1992

In any country the weather creates many different conditions of light and atmosphere, and so there are lots of variations in the way that subjects can appear and appeal to us. For instance, on an overcast day, a scene may look quite ordinary and uneventful. But later, with the sun shining and creating strong lights and darks, or in a downpour with dark sky and reflections, everything becomes far more interesting. Light is the critical factor and with this in mind all types of weather can offer potential for exciting paintings. I have painted in the heat and the snow, as well as

Below: **The Blue Umbrella, Morocco** *39 × 28 cm (15¼ × 11 in). It is not necessary to be put off by rain as long as you can find a sheltered spot to look out from, as I did in this museum in Fes.*

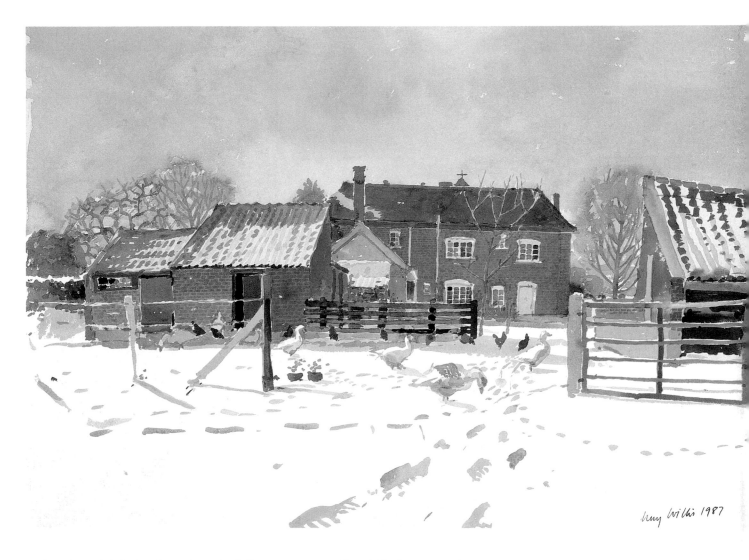

Lucy Willis 1987

in the rain and the mist. Sometimes, in dull conditions, the lighting effects may need exaggerating to make the painting work, but it is normally a question of weighing up the possibilities of a scene and realising that if it works as an inspiring image in nature it should work as a painting.

Whatever the weather there are two further points to consider: your own comfort, and how the conditions will influence the way the paint can be mixed and applied. On a cold day you need to

wrap up well and ideally not stay in one position for too long. I find that even on a mild day, once I am concentrating on my painting I can quickly become very cold without noticing. So it is best to overdress at first so you won't need to stop and warm up partway through. With these things attended to, a quick study of a frosty or snow-covered landscape, for example, can be very rewarding. Snow scenes certainly make an interesting contrast to painting the lush greens of summer and they offer

Above: **Farmyard in Snow, England** *43 × 64 cm (17 × 25 in). As long as you are well prepared, painting outside in the snow is very rewarding. With watercolour the white of the paper really comes into its own: the slightest wash on the sky makes the ground appear snow-covered.*

Above: Saint Simeon's Monastery, Aswan, Egypt 28 × 22 cm (11 × 8¹/₂ in). It is important to place yourself in a shady position, both as protection from the heat of the sun and to allow your watercolour a little more time to dry. If the sun falls directly on your paper the water in your washes will evaporate before you have time to spread out the paint, causing hard edges where you don't want them.

exciting possibilities for exploring the full tonal range, from the white areas (using the white of the paper) to dark, silhouetted shapes and patterns. Toning down the sky, as in *Farmyard in Snow* (page 23), instantly lights up the snow-covered ground.

Similarly, in hot climates you also need to think carefully about what to wear and the choice of subject matter. Protection from the sun is vital to the success of working in such conditions. A hat is important, not only to avoid sunstroke but

to keep the glare out of your eyes so that you can see your subject clearly. Be aware too that, when sitting still for any length of time, absorbed in your work, you may not notice the strength of the sun. There have been many times when I have finished painting and suddenly realized that I have burnt my arm or foot. In India and Africa I found it was difficult to work during the middle of the day, because not only was it extremely hot, but also there wasn't much shade. In any case, with the sun high overhead, the light is stark and glaring, and few subjects look their best in such conditions. Consequently in hot countries I like to get up early and paint, and then work again in the afternoon as the shadows lengthen.

Humidity and temperature are the principal factors that affect paint drying – obviously in hot conditions the paint dries quickly. You can overcome this to an extent by adding more water to the mixes, although if you add too much the colours become very weak and it is difficult to achieve the necessary depth of tones. Experiment – with practice you learn to gauge the right amount of water so that the paint is fluid enough to manipulate, yet does not dry immediately it touches the paper.

If possible, keep your paper in the shade, because this keeps it slightly cooler as well as reducing the glare from its surface. An

advantage of painting in sunny, hot conditions, however, is that because the paint dries so fast, you can quickly apply one wash against another without fearing that they might bleed. When painting on cold, damp or humid days, of course, the opposite is true. The paint doesn't dry very quickly and therefore, if you want to juxtapose washes and not let them merge together, you need to leave little white gaps between one patch of colour and another. These can be touched in later if they are too noticeable. You soon get a feel for the prevalent conditions and learn to make the necessary adjustments.

Crowds

'It is no easy matter to pursue the fine arts in Monastir … for all the passers-by, having inspected my sketching, frown or look ugly, and many say "Shaitan", which means Devil; at length one quietly wrenches my book away and shutting it up returns it to me saying "Yok, Yok!" (No, No!) So as numbers are against me, I bow and retire.'

From Edward Lear, *Albanian Journal*, 1848

An artist painting on the spot is an unusual sight in some countries and naturally people are inquisitive. At first, a crowd gathering around you can seem a bit intimidating and inhibiting, but after a while you learn to accept that this will happen in certain places and you continue working as best you can. My experience is that people are usually very interested and enthusiastic about the painting. In fact, very often they want to be in it.

Occasionally, I admit, groups of children can be a nuisance. I've known children dip their fingers into my paints to see if they are edible, and once I was suddenly aware of a sinking feeling when a boy in the crowd discovered that he could pull the stopper out of the inflatable cushion I was sitting on. There was great hilarity as he repeatedly tried to reinflate the cushion while I sat tight trying to carry on painting. But my hand was unsteady because I was laughing so much, and my vision was blurred by the tears rolling down my cheeks!

Below: **Camel Market, Egypt**
20 × 30 cm (8 × 12 in). This was a bustling event thronging with people, so I positioned myself with my back against a car and screened by a bit of a hedge, so I wasn't too much of a curiosity to the local children.

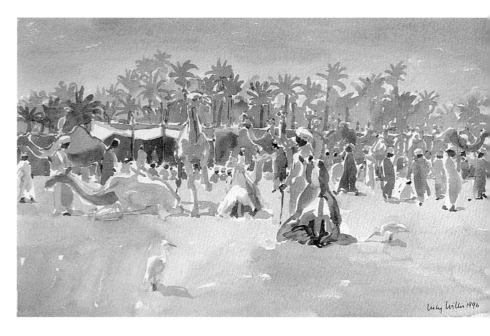

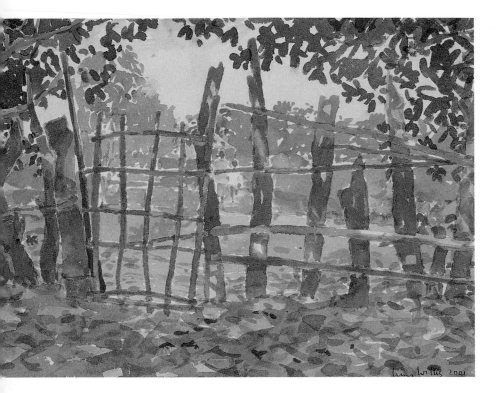

*Above: **Stick Gate in the Cashew Walk, Senegal, Africa** 29 × 39 cm (11¹/₂ × 15¹/₄ in). Just as with grander architectural subjects, humble structures like this, analysed through painting, give an insight into the lives of local inhabitants as well as a wonderful visual complexity of soft, muted colours and dappled shade.*

lessen any tension created by crowds, or you could find locations where groups of people are less likely to gather. Certainly it is wise to avoid obvious tourist spots.

If it all becomes too overwhelming there are usually some quiet corners from which to paint, whether these are within a magnificent church or other fine building, beneath a shady archway overlooking the street, or somewhere in the hotel where you are staying.

Choosing Ideas

'Through charm, or the preliminary idea, the painter achieves universality. It is charm that decides the choice of subject and corresponds precisely to the painting. If this charm, this preliminary idea, fades away, nothing is left but the motif, the object, which thrusts itself upon the painter and dominates him. After that his painting is no longer his.'

Pierre Bonnard, from *Bonnard*, André Fernigier, Thames & Hudson, London, 1987

In this kind of situation I like to find an older boy or young adult in the crowd who speaks English, and employ him (sometimes for a small fee) to keep the crowd under control. One difficulty is that, in their curiosity, people inadvertently block your line of vision and you have to ask them politely to move so that you can see your subject. Although I have painted on my own in many countries, I have only occasionally felt physically threatened. Nevertheless, my advice – to women especially – would be to choose a spot that is not too quiet and remote, where you could feel vulnerable. Painting alongside someone else helps to

Choosing ideas is always a subjective process, although most artists will agree that subject matter does not have to be obviously beautiful, colourful or complex to work as a successful painting. The desire to paint can come from a wide variety of

sources, and frequently it is something small and unusual about a subject that first attracts our attention. It may, for example, be how the light catches a particular surface, a bold patch of colour, the detail on the façade of a building, or the stance of a distant figure. Different qualities appeal to different artists. Faced with the same subject, each member of a group of painters will make their own individual response, and this is how it should be. When I visit other countries it is often the architecture that inspires me. I especially like scenes that demonstrate the relationship between buildings and people, as in *The Square, Sana'a* (below), and invariably, as here, I will choose a building or part of a building because of a certain way the light falls on it.

The first morning in an unfamiliar city or other new location can present an overwhelming variety of things to paint. So where do you start? My advice is to ignore the broad vistas to begin with, as these can be rather complicated. Instead, home in on

*Below: **The Square, Sana'a, Yemen** 43 × 64 cm (17 × 25 in). The unexpected splendour of the houses in this ancient mud city was an inspiration in itself. In choosing a view to paint I was struck here by the glow of reflected light in the receding alleyway, and that became the pivot of the larger composition.*

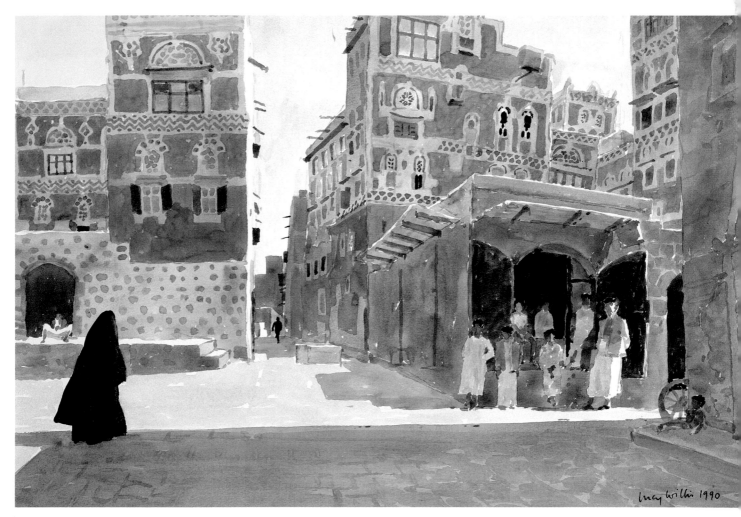

a detail, something that you can paint quickly and successfully and will get you looking and thinking. You could focus on an architectural detail, for example, such as a decorative arched window, or you could try painting individual figures, concentrating on the pose and shapes they make. If you are painting in a garden or find yourself in the African jungle, as I did with *Bush in the Bush* (below), you could select a particular detail of foliage. This approach will give you some confidence

and, while you are painting, you will also begin to form an impression of the place and no doubt notice other, more elaborate subjects that you could try later.

If you are staying somewhere for any length of time it is a good idea to spend the first few hours just walking around to see what there is. Make a note of potential ideas and subjects that you could return to. However, in choosing any subject you also have to bear in mind various practical considerations. Quite often there has to be a compromise between painting from the ideal viewpoint, which may be impractical for some reason, and finding a spot that is fairly quiet and is out of the sun. Occasionally you may come across the perfect subject but there is nowhere that you can comfortably work from. Here, the best solution is to make a few quick notes and pencil sketches, and perhaps take one or two photographs. Use these as the reference material for some paintings when you get back home. Also, when you are assessing the potential of an idea for a painting, you need to think about how it is going to work in terms of the composition, which in turn will affect the size of the paper you choose and the scale of the image. You will also need to consider the light and shadows, which will create a certain mood and impact.

*Below: **Bush in the Bush, Senegal, Africa** 30 × 25 cm (12 × 10 in). An apparently unremarkable bit of foliage can become the inspiration for a watercolour. I walked past this little sapling a couple of times before painting it, each time noticing how the young leaves glowed in the light filtering through the surrounding trees.*

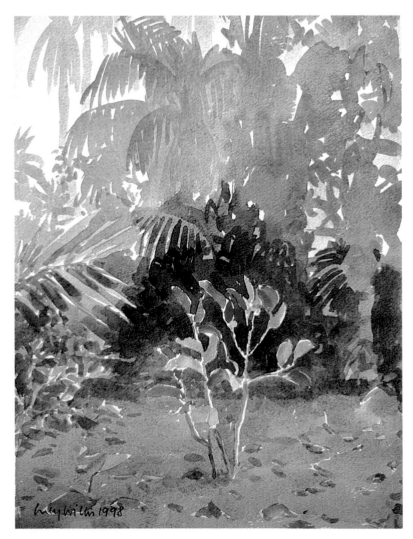

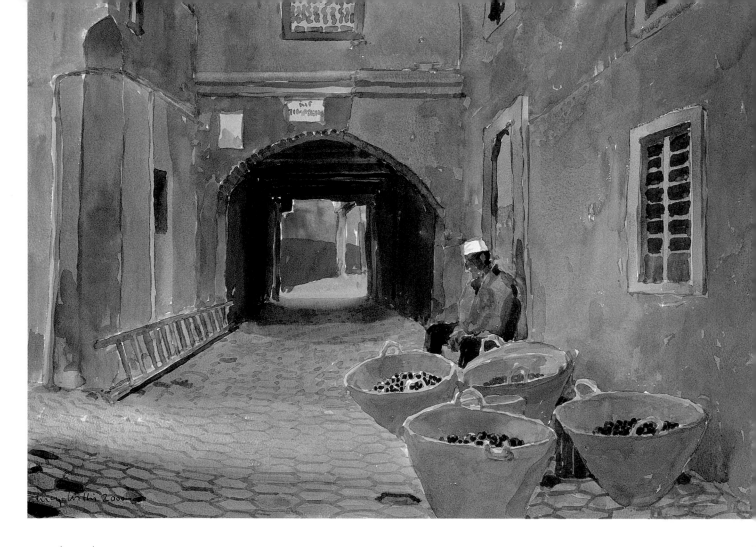

Inspiration

'Painting is with me another word for feeling.'

John Constable, from *Constable*, John Sunderland,
Phaidon Press, London, 1992

Finding inspiration may not be that difficult, but how do you sustain the enthusiasm for an idea once the painting is under way, especially if things start to go wrong? I think the best approach is to decide what you feel is important about the subject, for example the yellow glow behind the tunnel in *The Olive Seller* (above), and try always to keep this in mind while you are painting. I made sure that nothing else in the composition competed with the intensity of that crucial central colour and tried to keep everything else muted in comparison. So, concentrate on those qualities that initially most impressed you. Other aspects may become apparent during the painting process, but try to avoid the temptation to be diverted from your initial aims or to go into irrelevant detail. As you assess your progress you may want to make some adjustments to the overall idea and objectives you had originally planned, but try not to lose sight of what it was that first attracted you to the subject. If you notice other ideas and possibilities, save these for another painting.

Above: **The Olive Seller, Meknes, Morocco** *43 × 64 cm (17 × 25 in). It took a while, wandering the streets of this town for the first time, to find a subject to paint. But when I saw this passage, lit at the end with yellow, I immediately looked around for a place to sit and fortunately found one that gave me just the right vantage point.*

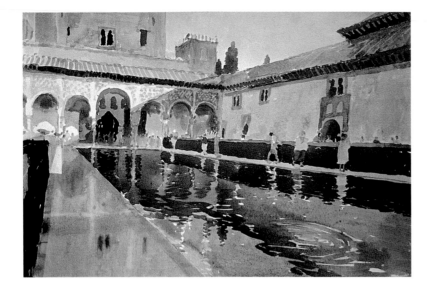

Above: **The Court of the Myrtles, The Alhambra, Spain** *41 × 58 cm (16 × 22 ¹⁄₄). I was keen to catch the orange reflection in the water and so took up my painting position on a strategic path. Unfortunately it was periodically the thoroughfare for large and oblivious parties of tourists. But from this position I was able to include the building in the distance, to which all paths and lines of perspective led, as well as its coveted orange reflection in the water.*

several hours available I was able to sit down and make this composition from the only possible vantage point, which luckily gave me a good view of the tank and the water running towards me.

A knowledge of various theories and compositional devices is useful, providing these do not rigidly dictate the way you work. They include such well-known formulae as setting the main focus of the picture off-centre and placing the horizon line two thirds of the way up the paper. I

Composition

The success of a painting, both in terms of being satisfying to the eye and in the way that it conveys ideas and images with some impact, depends on sound composition. There has to be a sense of order and design but most artists realize that if the composition is too contrived the painting will lack vigour and sensitivity. When painting on your travels it is good to have an open mind and be prepared to compose a picture spontaneously, often of an unexpected subject, with minimal but careful forethought. This was so with *Mountain Water System* (right). Walking in the hills above a village in southern Spain I was surprised to come across a high reservoir for irrigating the orchards. As I was carrying my painting gear and had

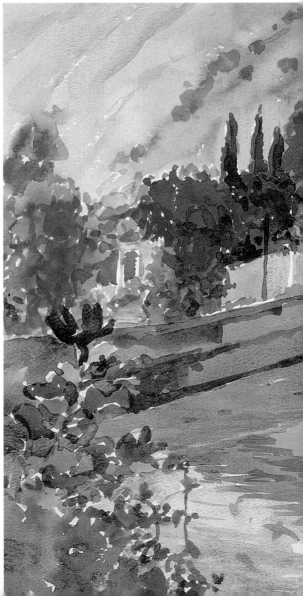

like to keep these principles at the back of my mind, but in the main I try to work fairly intuitively.

Usually the subject itself suggests an interesting composition, although you may need to simplify some parts, leaving things out, and perhaps introducing shapes in other areas. Most artists like to break the 'rules' now and again. For example, I sometimes feel that the composition has more impact if I place the focal point right in the centre of the painting. Shapes that

meet in the centre, such as the two sides of the building in *Court of the Myrtles* (left), can be counterbalanced by strong diagonals and other elements within the painting that are asymmetrical.

The composition is important as the underlying structure or framework on which to build and develop the painting; equally, it is a way of directing the viewer's attention to the centre of interest or focal point. But there is more to composition than just designing with shapes. The placing

Below: **Mountain Water System, Frigilliana, Spain** *38 × 56 cm (15 × 22 in). The composition here was partly determined by the only available painting position, but I liked the way the straight lines of perspective drew you towards the clutch of buildings and beyond to the distant hills.*

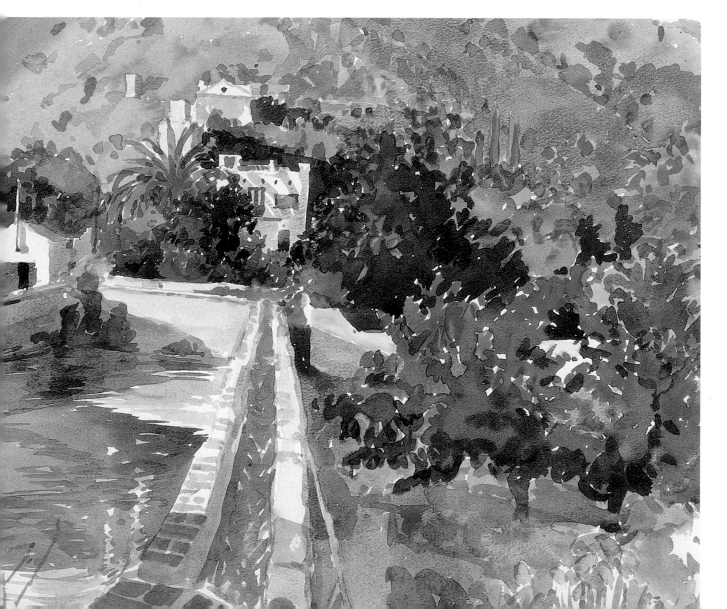

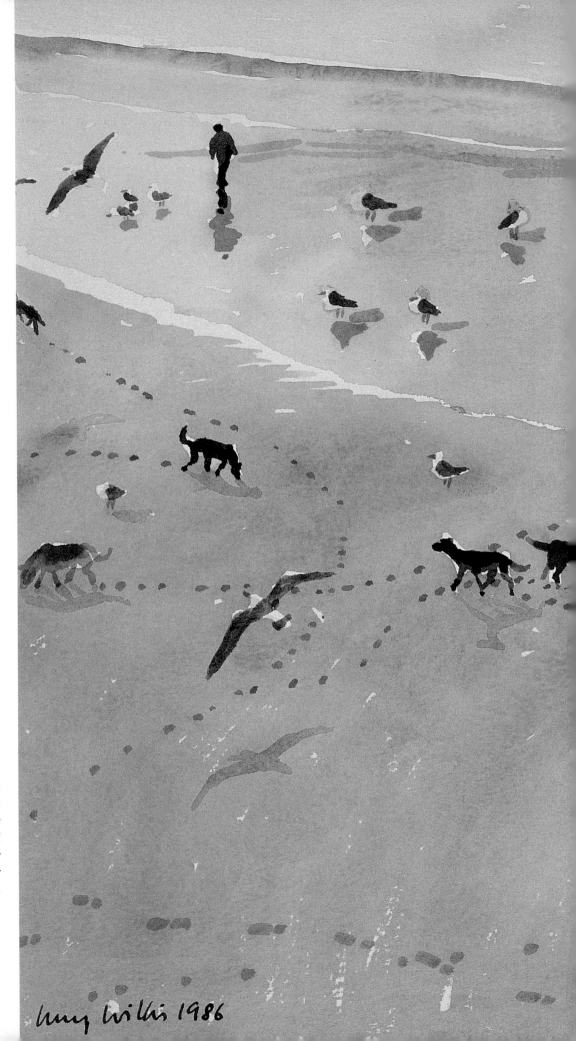

Right: **Gulls on the beach, Albufeira, Portugal** *30 × 35 cm (12 × 13 ¾). A view from above offers an unusual composition. I wanted a simple structure to my painting: just bands of colour dotted with points of interest.*

Lucy Willis 1986

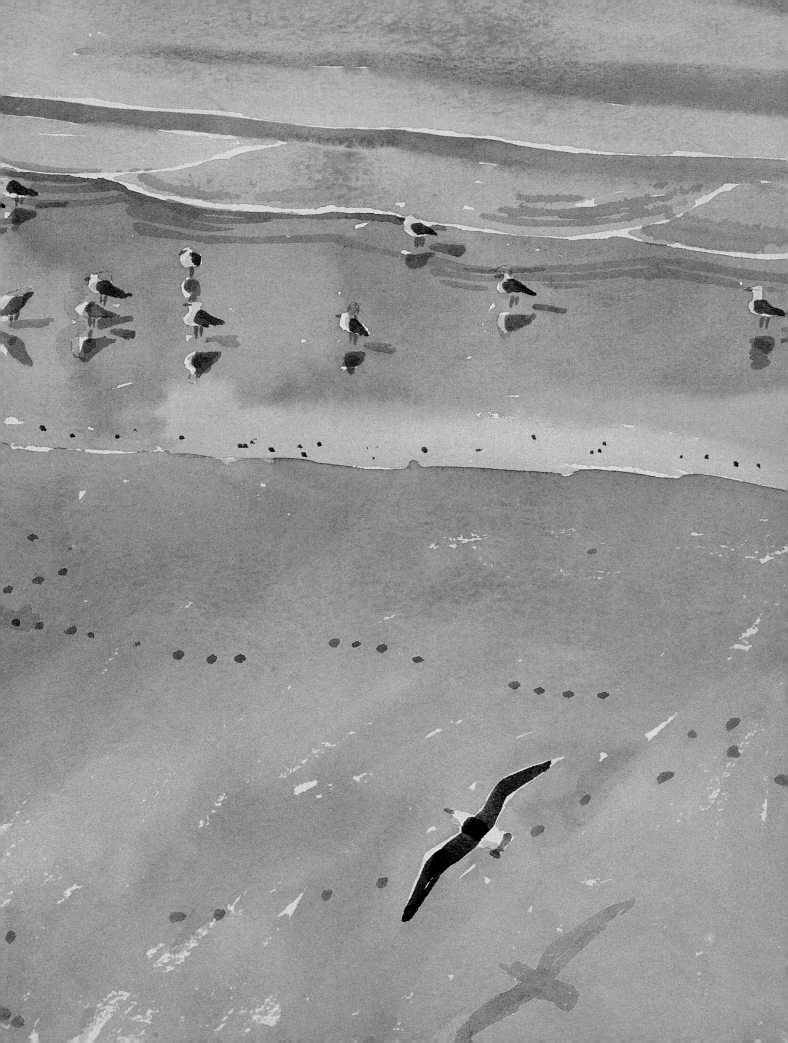

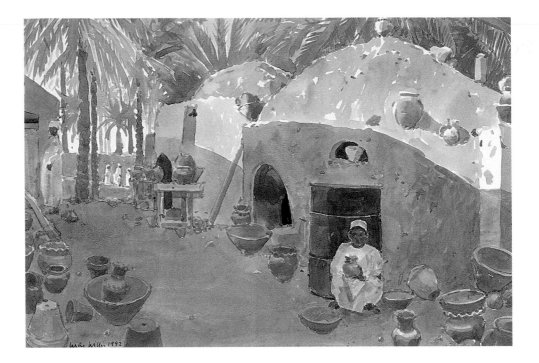

Above: **The Pottery Boy, Bahla, Oman** *43 × 64 cm (17 × 25 in). The shadows falling on the mud kilns presented an unusual composition. By including the structures on the left and leaving the foreground relatively empty I emphasized the path winding between the pots into the distance.*

and relationships of tones and colours must also be considered, as must the way that empty spaces complement areas of activity and interest. A very busy, cluttered composition can sometimes work, but normally passages of strong colour or intense interest need balancing with areas of calm. A successful composition will have both unity and variety. Here the artist has a wide vocabulary at his disposal: contrasts, rhythm, repetition, harmony, and balance and counterbalance.

Once you have found the subject that you want to paint, assessed the practical considerations, and chosen the viewpoint you are going to work from, you might need some help to 'frame' the scene. You can make a simple viewfinder to carry around with you by taking a small sheet of card (for example, A5-size) and cutting out a small rectangle in the middle. Looking through the hole, as if you were looking through the lens of a camera, will help you decide what to include and what to leave out of the scene.

Whether you use a viewfinder or not (I personally am happy to judge things by eye) the basis of the composition will be determined by whatever element within the subject you decide is going to be the focal point. It can help to make some preliminary quick thumbnail sketches or composition

roughs. These will give you an indication of whether or not the general layout of your subject matter is going to work. You can also lightly draw the basic layout on to your watercolour paper in pencil before you start to paint. But at this stage try not to resolve the composition to such an extent that when it comes to the actual painting all you are doing is following the design and filling in shapes. Keep some flexibility to adapt and change things while the painting is actually in progress.

When making decisions about the composition of a painting, don't be afraid to simplify what you see or modify or add extra elements if you think this will create greater impact – providing that this isn't at the expense of losing sight of your main subject, as mentioned earlier. Remember too that, if necessary, you can make further improvements to your work when you get back home. Sometimes, for instance, I add another figure or introduce a foreground shadow if I think a little extra interest is required. In *Pottery Boy, Bahla* (left) I added more pots to the foreground to help bring this forward and increase the feeling of depth in the painting.

Below: **The Wedding Tent, Udaipur, India** *41 × 58 cm (16 × 22¼ in). Having noticed the best time for this combination of sun and shadows the previous day, I returned ready to start painting – only to find that in the meantime a wedding tent had been put up in one of the arches and musicians were beginning to play – an unexpected bonus.*

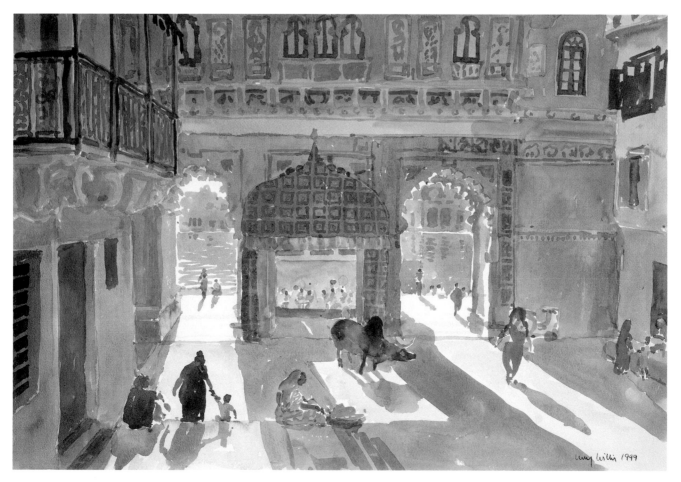

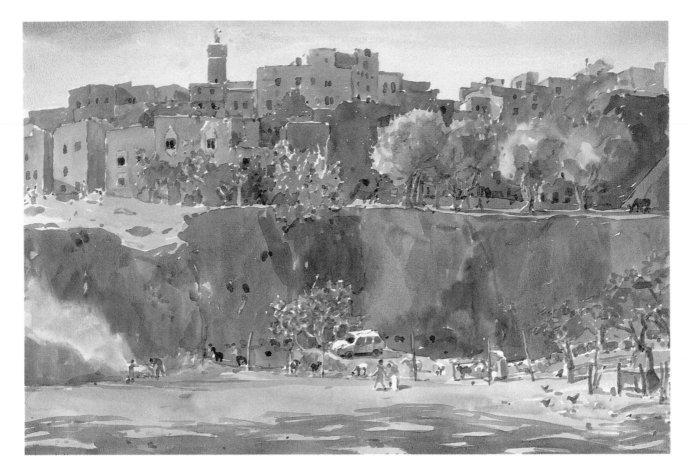

Light and Shadows

Variations of light produce an extraordinary range of effects and moods, even within a single subject, and an awareness of this creates immense potential for exciting paintings. Dramatic effects occur in bright, sunny conditions, where there are sharp contrasts between areas in full light and those in deep shadow. However, you will also notice interesting qualities on overcast days, when the shadows and contrasts are more subtle, or when there is dappled light or, at night, artificial light. Often it is the play of light and shadow that initially attracts an artist to a particular subject and which remains one of the most important

elements as the painting is developed. *The Wedding Tent* (page 35) is a good example of this. I passed this well-known scene at various times of the day in my explorations of Udaipur, India, and decided that evening was the best time to paint it. When I returned ready to paint the elongated shadows I discovered a wedding tent and musicians had appeared between the arches, adding another dimension to my composition.

Light and shade not only enliven a painting, they are useful in other respects too. They help define shapes and suggest three-dimensional form, as on the kilns in *The Pottery Boy, Bahla* (page 34), and they

can play a significant part in the composition of a painting. Also a cast shadow, such as from the tree in *Darricha, Fes* (left), is a good way to break up and add interest to a large foreground area.

When you start a painting it is important to note carefully the direction of cast shadows, for obviously they must tie in with the source of light and the shape and position of the object they relate to. Think also about their tone and hue – they are rarely just grey, but contain a subtle variety of colours. With watercolour you can add shadows as a superimposed transparent wash, so that shapes and details already painted will show through, or you can paint the shadow tone first and add any necessary detail over this.

The quality of light and the intensity and direction of shadows obviously change with the movement of the sun as the day progresses (for instance, see the *Overlooking Fes* series below). This means that whenever you are working outside in sunlight there is a very limited amount of time in which to work on a painting in the same type of light – usually only about an hour when it is very sunny (though remember that shadows shorten and lengthen most quickly at the beginning and end of the day). You could, of course, return to the subject at the same time the following day, or for several days, if you want to work in some detail and you need more time to finish the painting. For a large painting I will sometimes spend two sessions at a particular location. I find that if I return for a third time the painting begins to feel laboured: it is in danger of losing the freshness that for me is so much a part of a successful watercolour. Alternatively, you could decide to work on

Below:
Overlooking Fes, Morocco, 6.00 am
Overlooking Fes, Morocco, 6.20 am
Overlooking Fes, Morocco, 7.05 am
Overlooking Fes, Morocco, 5.40 pm
all 29 × 19 cm (11 ¹/₂ × 7 ¹/₂ in)
Right outside my hotel window, against a backdrop of the ancient city, was a pair of soaring palm trees. Each time I looked out their appearance had changed and I started a series of seven studies in an attempt to capture their mood at different times of day. These four show the difference that the changing light can make during the course of the day.

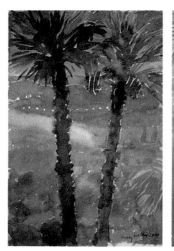
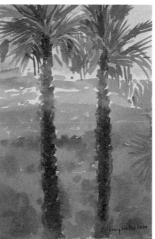
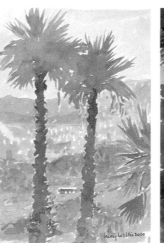
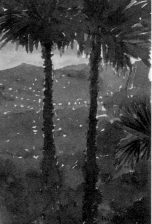

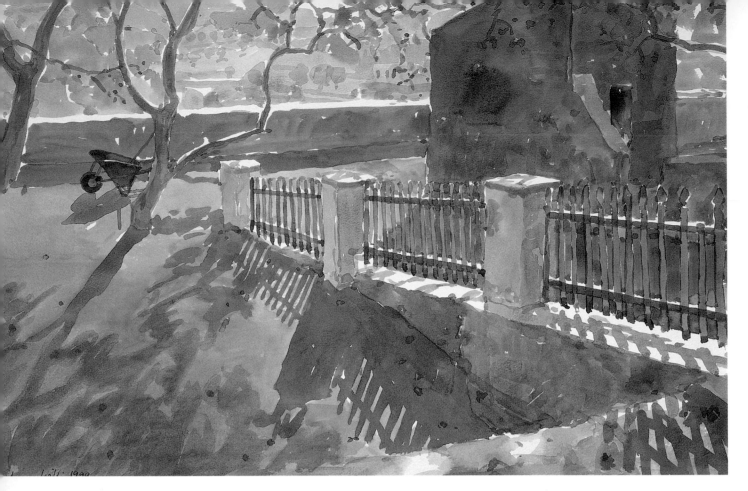

a smaller scale and aim to complete the painting in one session.

Whichever approach you adopt, I find it is best to fix the position of the shadows at a particular point early on in the painting and keep to this. Avoid a situation in which you plot some of the shadows at the beginning and then forget to put in the rest until the sun has moved and the new shadow angles don't match the earlier ones. It isn't necessary to paint the shadows completely at this stage, but at least make pencil marks or reference points with paint to remind you where they should go. You may even find it helps to make a quick tonal sketch before you start painting to help you record where the main lights and darks should be.

Techniques

'In painting, as in literature, the poetry does not exist if the technique is not sufficient to express it.'

D S MacColl (*Spectator*, 1893)

On every trip you will need to adapt to a variety of situations as well as to the constraints of time and other factors. In this section I discuss some of the techniques that I have found successful, adding alternative suggestions. My main advice here would be that the wider your repertoire of techniques and the greater your experience with them, the better equipped you will be to deal with different locations and situations.

sketching

'Strolling on the boulevards in Paris, Manet would sketch in his notebook a nothing, a profile, a hat … in a word a fleeting impression.'

Antonin Proust, Edouard Manet's biographer

Because I tend to think in terms of watercolour, I like to work directly with the medium whenever possible, even when time is limited. So, assuming the conditions are favourable and I have my paints with me, I would much rather make a quick, ten-minute watercolour painting, as with *Boats on the Bosphorus* (right), than spend the time producing a reference sketch in another medium.

However, sometimes it is impractical to paint on the spot – when travelling in a train, for example, or waiting at an airport. But there are always ideas and subjects that interest me, so in these situations I draw and make notes in my sketchbook. Mostly my drawings are of people: studies showing different poses, activities, characters and so on. This means that later, if I want to add some figures to a painting, I have plenty of informative drawings to refer to. Yet, having said this, I don't feel obliged to use my drawings for any particular purpose, and certainly I believe drawings need not be made with some ulterior motive in mind.

They don't have to be 'useful', for they have a validity in their own right.

There are several reasons why it is important to draw as often as you can. Perhaps foremost among these is the fact

Below: **Boats on the Bosphorus, Turkey** *20 × 25 cm (8 × 10 in). I wanted to paint a quick impression of the skyline of Istanbul receding as we chugged away from it.*

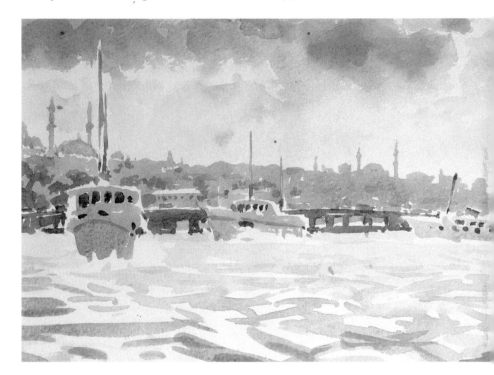

Above: **Woman in Pink, France**
20 × 15 cm (8 × 6 in),
water-soluble crayon sticks.
Sitting at a table with a group of
people it was possible to do a
quick coloured drawing without
attracting too much attention.

Right: **Nubian House**
20 × 15 cm (8 × 6 in),
water-soluble crayon sticks.
With these crayons you can
dissolve the colour with water,
giving a hint of watercolour
wash without the bother of
getting out the paintbox.

that drawing helps you to develop your observation skills. It encourages you to look, analyse and make decisions about what you see. In turn, this enables you to interpret different shapes, proportions, tones and colours in a confident and convincing way. By doing lots of studies in your sketchbook, even though you may not use them for any other purpose, you will gradually build up a knowledge and experience that will assist you whenever you need to draw something. It follows that drawing skills are a particularly important foundation when working in watercolour, because once the medium is applied it is difficult to make any alterations. The initial, underlying drawing must always be sound.

Sketching Media

The media I like to use for sketching include ordinary graphite pencil, coloured and water-soluble pencil, and black ballpoint or rollerball pen. The exact choice of medium

depends on the subject matter and my aim for the sketch. For example, sometimes I decide to concentrate on a tonal study using an ordinary pencil or rollerball pen to convey the chiaroscuro (light and dark) qualities of the subject. Incidentally, this is always a worthwhile exercise, as an understanding of tone is a key element in successful watercolour painting.

In other sketches I might focus on line and shape, perhaps with one or two written notes to remind me of significant qualities, or I will work in monochrome or a limited range of colours. Here, I often choose traditional coloured pencils, although sometimes I enjoy drawing with water-soluble coloured pencils or sticks (such as those produced by Caran d'Ache), which can be wetted to fill out the colour with a kind of wash effect.

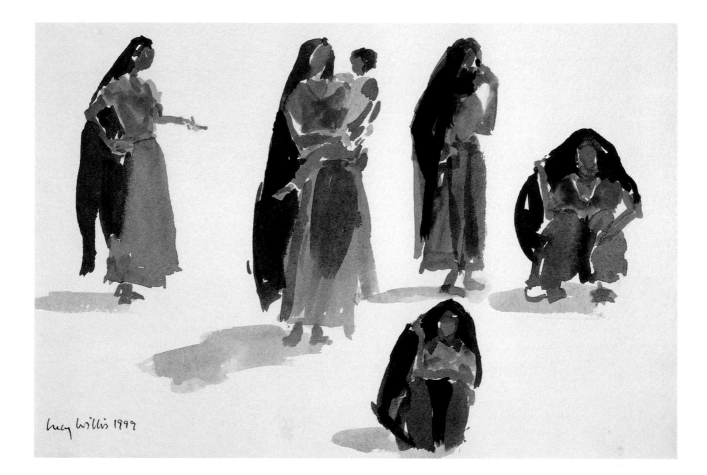

lucy willis 1999

When I am making a sketch specifically for a watercolour painting, as with the *Verdi Requiem* sketch (page 109), my aim is to ensure that I have the viewpoint and composition that I feel will work best. Then I will include just enough information to remind me of the qualities that most impressed me. Also, I may add a note of the tonal range or indicate an unusual colour or a particularly interesting detail or architectural feature. But essentially I see a sketch as an *aide-mémoire* and I think it is important to work as much from one's own memory of the scene as from specific visual information. I find I can usually get all the necessary reference in a single sketch, although I often work across a double page of my sketchbook.

However, as mentioned earlier, I recommend the watercolour medium itself for small, quick studies where this is practically feasible. For these, I use exactly

*Above: **Rabari Tribeswomen, Kutch, India** 21 × 28 cm (8¼ × 11 in). During a visit to a Rabari village this woman was happy to stand and pose in a casual way, enabling me to do a number of quick studies on a single sheet, moving on to a new one whenever she changed pose or picked up her child.*

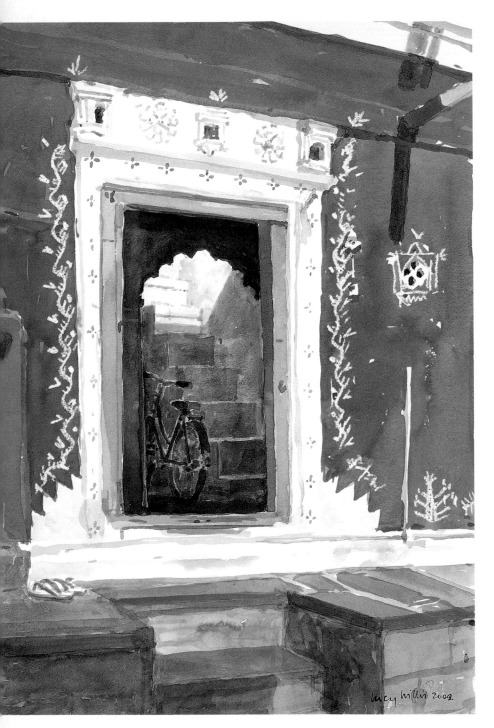

the same approach that I would adopt for a larger, more resolved work – the difference is simply in the scale, the speed and the scope of the subject matter. Such paintings need only be postcard-size, yet they can still convey a lot of feeling and meaning.

Photographs

For me, working from photographs is a last resort. They are seldom as good as a sketch because using a camera doesn't encourage you to spend any length of time in front of the subject making your own assessment of its distinct qualities and potential. Ordinary snapshots cannot emphasize things or interpret what is there; they are merely a record of the scene. Nevertheless, if there is no time for sketching or painting then a photograph can be extremely helpful. But again, try to use it as an *aide-mémoire* to rekindle the excitement you felt at the scene, and bear in mind that the camera very often distorts tones and colours and exaggerates distance and perspective. Also, if for some reason you have to stop painting halfway through a watercolour – perhaps because the light begins to change or a big vehicle parks in front of you – a photograph taken at the right moment can help you finish the painting later.

Colour

While there can be a lot of variation in the intensity and range of colours from one subject to the next, I rarely find it necessary to make any fundamental changes to my basic palette. In fact, in my travels I often come across some very colourful sights: the saris worn by many women in India are a good example. But for this type of subject, although I may introduce one or two additional colours to my usual selection, it otherwise remains the same. There is no need, I think, to make radical changes to the palette to suit different countries and

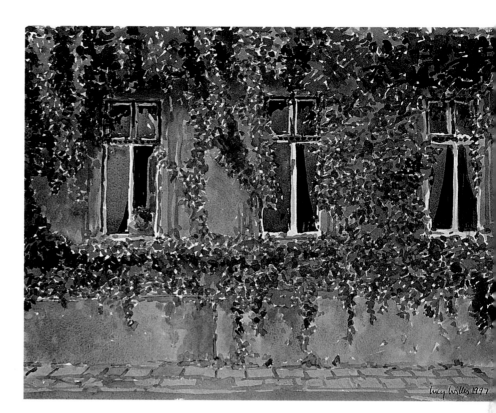

*Opposite page: **The Red Bicycle, Jaisalmer, India** 64 × 43 cm (25 × 17 in). I try not to feel constrained to stick to what is there when working from a photograph. Although the wall came out clearly in the photograph, the space inside the doorway appeared almost black, so I lightened it considerably and added a bicycle.*

*Above: **Virginia Creeper, Vesprem, Hungary** 22 × 30 cm (8¹/₂ × 12 in). When I go abroad I take a small supply of colours rarely called upon in England, including the cobalt turquoise used here.*

*Left: **Sleeping Boatman, Aswan, Egypt** 35 × 39 cm (13¹/₄ × 15¹/₄ in). I used a limited range of colours – yellow ochre, cerulean blue, violet and sap green – to mix a wide variety of greys, greens and subtle browns.*

climates. In my experience there are rich, colourful subjects as well as more subtle ones in every part of the world – just as there are bright, sunny days (if fewer of these in England than in India) and very dull ones wherever you go.

Observing Colour

Before starting a painting I think it is important to make a general assessment of the distribution of colours within the subject and their relative warmth and coolness. This helps not only in deciding which colours to concentrate on but also in judging how these colours can be used to create the most impact.

The warm colours include yellows, reds and oranges, while the cool colours are greens, blues and purples. However, every colour has a relative degree of warmth and

coolness so that cadmium red, for example, is a warm red in contrast to alizarin crimson, which is much cooler. Noticing how a particular colour changes in its relative warmth and coolness as it crosses the surface of an object will help you depict the three-dimensional form of that object more convincingly. Also, the contrasts between warm and cool colours can be exploited to add further interest in a painting.

Tone

Another essential aspect to consider when painting is the tonal range – the relative light and dark values of the various shapes that make up your subject. Irrespective of the actual or local colours of these shapes you will need to estimate how light or dark each one is in relation to everything else. The principal factor in determining these tonal variations is, of course, the intensity and play of light. If you were painting a blue house, for example, although you know it to be the same colour all over, you would notice that the side of the house facing the light is a very different tone to the one that is in shadow.

Estimating the tone of a colour can be quite difficult, although with practice it soon becomes second nature to see things in terms of tone, and there are a number of techniques that can help you. One such technique, which is always useful, is to half-

*Below: **Girl on the Stairs, Greece** 43 × 64 cm (17 × 25 in). The overall colour scheme of the interior is cool and muted, which adds to the intensity of the warm colours seen through the open door.*

*Opposite page bottom: **Nubian Dream, Aswan, Egypt** 42 × 58 cm (16¹/₂ × 22¹/₄ in). I was enchanted by the Nubian mud houses, which are often painted blue to match the sky. At this time of the day they are almost lost, defined only by some small and subtle changes in colour and tone and occasional windows and doors.*

close your eyes as you look at the subject.
This not only helps to enhance your
perception of tone, rather than colour, but
it also gives a more general, simplified view
of the tonal distribution and range. Looking
at the subject in this way, you could make a
quick tonal sketch before starting the actual
painting, subsequently using the sketch to
remind you of the main tones. This is
especially helpful on days when the light is
constantly changing.

Tonal sketching in general, leaving out
the lines and concentrating only on
observing the relationships between light
and shade, is essential groundwork for the
watercolourist. Tonal studies made at home,
for example of simple forms such as apples
and pears, can stand you in good stead
when faced with the hustle and bustle of a
foreign painting trip.

The ability to see objects in terms of
their tonal value as well as their colour will
enable you to interpret them more
successfully, for it is primarily the
differences of tone across the surface of
something that describe its three-
dimensional form. Here again, the light
source plays a key role, so that on a
rounded object, for example, the surface
may be light, then mid-toned, then dark.
With most subjects tackled in watercolour
you will find that it is possible to simplify
tones in order to convey quickly an effect

that looks convincing. As in any aspect of
painting, being too literal usually leads to a
rather complicated and consequently less
effective result.

Top: **Red Wall, Jaisalmer, India**
12 × 15 cm (4¹/₄ × 6 in).
*It is tone as much as colour that
defines these figures, sunlit
against a deep red wall.*

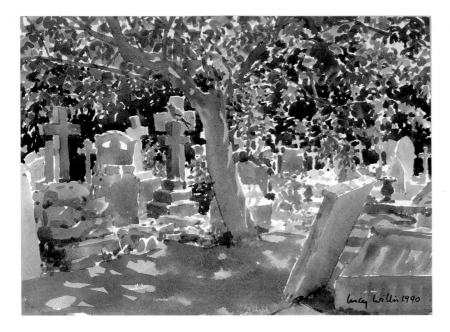

Above: **Jay in the Cemetery,**
England *30 × 38 cm*
(12 × 15 in). Amid dappled light
and shade from overhanging trees,
a few crucial tonal contrasts define
the shapes against their back-
ground, and also the visiting jay
when it flew into the picture at an
appropriate moment.

The techniques concerning tone that I often intuitively use in my paintings to enhance the feeling of light and help define one shape against another are tonal counterchange, and what is known as 'lost and found edges'. Counterchange involves using the contrasting effects of placing light shapes against dark, as with the crosses in

Jay in the Cemetery (left), and dark against light. Similarly, with 'lost and found edges', sometimes the tones of the outline of an object and the background will be equal ('lost') while in other places there is a positive difference ('found'). In order to make these gradations in tone successfully you need to be able to mix colours.

Mixing Colours

Watercolour pigments vary in their characteristics. Most colours are transparent, but there are some that are opaque and others, known as staining colours, which quickly sink into the paper surface and consequently are much more difficult to lift out once applied. Similarly, pigments differ in their tinting strength. Ultramarine blue, for example, is a very powerful colour, so only a tiny amount of pigment is required when mixing a wash.

As well as mixing colours on your palette, aiming to hit the right note first time, you can also mix them in various ways on the paper. Try working wet-over-dry: applying a wet colour over a dry one to create a different colour; or wet-in-wet: placing two or three wet colours side by side and allowing them to run into each other. Depending on the subject, I often use all of these techniques in my watercolours, such as in *Evening at the Palace, Bhuj* (above right).

However, before committing a new colour to a painting you may want to test it out on a scrap piece of paper to check if it seems right. Alternatively, you could adopt the method that I use, which is to apply a small dot of colour to the painting itself. If this looks wrong, then I adjust the colour before filling in the whole area.

You can reduce the strength of a wash by adding more clean water and conversely you can enrich or modify the colour by the addition of a little more pigment, changing the colour or tone if required as you spread the paint. The clarity and crispness of a wash also depends on the way it is applied to the paper. The more a wash is 'worked' with a brush, especially when nearly dry, the greater the risk that it will become muddy-looking. Remember, too, that the

colours and tones in a painting are influenced by those around them. For instance, a bright colour will look all the brighter if it is surrounded by neutral colours or its complementary, as in *Remembering Bhuj* (page 99).

Using Watercolour's Strengths

'He began by pouring wet paint on to the paper till it was saturated. He tore, he scratched, he scrabbled at it in a kind of frenzy and the whole thing was chaos.'
A contemporary of Joseph Mallord William Turner describing the energy with which he handled his materials when producing a watercolour. From *Turner*, William Gaunt, Phaidon Press, London, 1992

Above: **Evening at the Palace, Bhuj, India** *41 × 58 cm (16 × 22¼ in). The edges of the main shadows have been softened with a brushful of clean water, while much of the architectural detail has been painted on top of an underlying wash, already dry.*

Opposite page bottom: **Sarah at Cliff Cottage, Cornwall** *30 × 38 cm (12 × 15 in). I had a complicated pattern of dark fence against dark wall here and the crucial thing was to leave the light sliver on the top of each piece of wood. The wall was defined in a series of negative spaces seen through the fence but had to be painted in such a way that each space matched the next to suggest a continuous wall.*

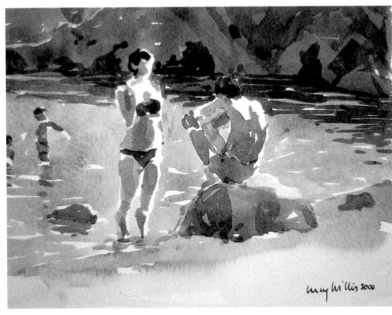

Above top: **Feluccas on the Nile, Egypt** *18 × 23 cm (7 × 9 in). As with any moving subject, it is important to try to catch the essence as quickly as possible.*

Above: **The Black Bikini, Greece** *12 × 15 cm (4¹/₄ × 6 in). Figures suggested briefly in a few strokes of flesh colour can then be thrown into relief by a more carefully applied background.*

Watercolour is an excellent medium for capturing subjects in a direct and spontaneous way and, as we have seen, this is one of the qualities that makes it ideal for painting on location. However, paintings are more than simply records of places and events: they can also convey a personal, emotional response. Expressing observations and feelings successfully in a painting relies to a large extent on choosing appropriate techniques. But this need not be a complicated process. In my paintings I like to make broad statements rather than attempt every single detail, and to do this I concentrate on techniques that help me produce clean, crisp and unlaboured results.

Economy of Means

To maintain a lively, translucent quality in your watercolours try to keep to the minimum number of washes. Whenever possible I try to capture a particular effect in a single application rather than using superimposed washes, because I find that with too many overlaid marks the freshness of colour is sometimes lost.

I'm also economical about drawing. You may find that making a preliminary pencil drawing works best for you, but personally I rarely make any pencil marks on the paper. Instead I 'draw' with a brush, making a sequence of dashes or small marks which indicate or plot the main shapes and help me note the highlights and other light areas that must be left unpainted. But I avoid making outlines with my brush – the little dots and dashes are more easily absorbed into the final painting than a continuous line. These marks are made with a colour that is roughly

appropriate to each passage in the picture, so I mix and change colours as I go along. As I start to apply the general washes I am careful to remember which parts should be left white, and I paint around these. You might prefer to use masking fluid for small or intricate shapes.

Another aspect where a restricted method of working can be helpful is colour. Although I may have a palette of up to 12 colours, I normally use only a few for each painting. As explained on page 14, a limited palette, perhaps as few as three colours, can give plenty of scope for different tones and harmonies. In any case, it is sound practice to simplify colours and to think in terms of tone as well as colour, and both these approaches can often work better with a limited palette.

Wash Techniques

Success in watercolour depends mainly on the ability to apply and control washes of colour. The two main types of wash, the flat wash and the graded wash, can be applied to either damp or dry paper. I always work on

*Below: **Temple of Harmony, Vesprem, Hungary** 50 × 61 cm (20 × 24 in). I like to imagine each mark or dot of colour, however small or intricate, as a 'wash' in its own right: applied and then left to settle and dry without disturbance. While one area dries I move on to another, my attention continuously jumping about the picture at the same time as keeping the overall scheme firmly in mind.*

dry paper because it allows more control and so helps to achieve the crisper, fresher and more clearly defined results I am generally aiming for. You can experiment with damp paper to give a more nebulous quality to your shapes, for instance, or to render the effect of light diffused in a hazy atmosphere.

The flat wash is useful when you want to cover a big area, such as part of the background, with a fairly even colour. Use a large brush and load it with plenty of colour. Apply the colour in sweeping, confident strokes. Then let it settle and dry without working back into it or manipulating it in any way. For a graded wash, on the other hand, the colour should be progressively weakened by adding more water to create a gradual transition from dark to light. A point to remember with all washes is that colours dry lighter than they look when first applied. I try to think of all my marks in watercolour as 'washes', however small, and to apply these principles throughout the painting.

As explained in the 'Mixing Colours' section (page 46), another technique is to run one wet colour into another. I often use this method when colours or tones change within shadows, for instance, or there is something that has no obvious hard edges. Otherwise, when you don't want colours to run together, it is a matter of waiting for one area of wash to dry before placing

another colour next to it. But in situations where I need to work quickly, and so there isn't time to let the paint dry, I simply leave a tiny spacing of dry paper between one area and the next. These spaces can be filled in later, if necessary.

Working Process

Even for a large painting like *Pink House among the Pines* (opposite and page 52), my ideal is to state everything in a single session, although I am flexible about going back and darkening or heightening areas of colour with a second or third wash if necessary. Each painting dictates the particular way I need to work. There is no formula that I adopt. But typically, having considered the composition, I start with a series of marks, as explained in 'Economy of Means' (above), at the same time checking the relative proportions and placing of things by using my brush, held at arm's length, as a visual measuring stick.

This gives me an indication of the structure of the painting and also reinforces in my mind exactly where I need to reserve the lightest areas as white paper. Then I begin with the areas of colour. From the outset I am thinking in terms of tone, and so immediately I will state shadows and areas of reflected light as well as passages of flat colour, where these are appropriate. Often I start with something

that is mid-tone and then something that is dark in tone, using these as a reference for estimating the tonal value of everything else in the painting.

With a large painting like *Pink House* (right and page 52), which may take more than one session of work, it is essential to establish the lights and darks as soon as possible, so that there isn't a problem if the light deteriorates or otherwise changes in some dramatic way. Using this approach, the whole picture area is built up in a kind of jigsaw fashion until it is completely covered except for the highlights, the very brightest areas which I leave as white paper. Then it is a matter of going back, reassessing and refining as necessary. Some shadows may need strengthening, some colours may need enriching, and the highlights toning down with a touch of very pale colour. In subjects that include specific detail, for example the intricate façade of a building, I paint the foundation colour, including the shadows, and then add the detail over this when it is dry, as I have done in *Evening at the Palace, Bhuj* (page 47).

The time to stop is, I think, at the moment when everything seems to work: when there is nothing that obviously needs attention. Judging that moment relies on experience, I suppose, but it is always better to stop when the painting is not quite

perfect than to press on with radical changes on the spot that could ruin it.

I prefer to take my paintings home in a fairly raw state and when I have time to look at them calmly I can consider what changes are really necessary. Often something I thought was not working when I was in front of the subject seems to fall into place when viewed from a distance in the studio – and of course the mistakes are obvious as well. Usually I am reluctant to try significant reworking or remedial measures because I think these can lead to muddy colours and damaged paper. But sometimes lifting out dried colour with a wet brush or a sponge (see the section 'Details and Alterations', page 104), or adding a little touch of colour here and there can, if used in moderation, work to pull everything together.

The three illustrations of *Pink House among the Pines* on page 51 and below demonstrate the main stages of my working process.

Below: **Pink House among the Pines** *42 × 58 cm (16¹/₂ × 22¹/₄ in)*

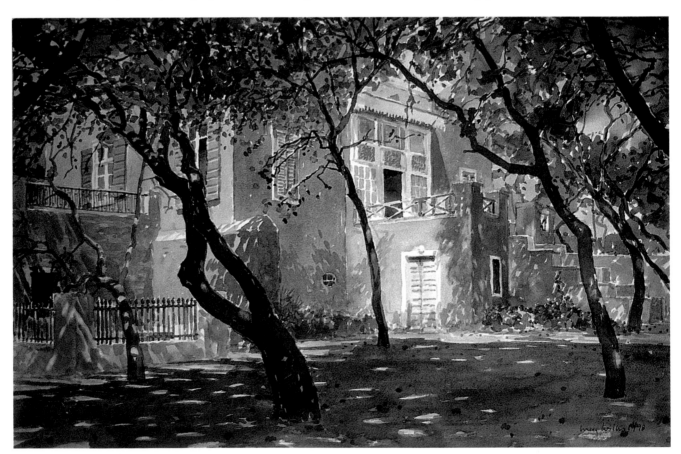

Lucy Willis 1999

Places and subjects

'I have always had a horror of theories; my only virtue is to have painted directly in front of nature, while trying to depict impressions made on me by the most fleeting effects.'

Claude Monet, 1926. From *Monet*, John House, Phaidon Press, London, 1992

For the travelling painter there is always an element of surprise. You are never sure what you will discover in the way of subject matter and this uncertainty can be exciting. When I am travelling, I find inspiration in a wide variety of subjects, from people to buildings and landscapes to interiors.

It is a mistake, I think, to play safe all the time and only paint those subjects that you know will succeed. Travel provides the perfect opportunity to be adventurous with ideas and approaches to your work, and this, in turn, is something that will add to your overall experience and development as an artist.

Landscapes

Landscape is a subject that offers immense potential and, on a long journey, it is fascinating to notice the changes that occur from one region to the next. Like architecture, landscape is something that

*Previous page: **The Front Steps, Greece** 58 × 42 cm (22¹/₂ × 16¹/₂ in).*

*Right: **Hillside by the Douro River, Portugal** 42 × 58 cm (16¹/₂ × 22³/₄ in). Dividing the picture almost diagonally, I wanted to give the impression of the terraced garden steeply tumbling towards the river below.*

Lucy Willis 2001

Above: **Island Terraces, Greece**
42 × 58 cm (16¹/₂ × 22¹/₄ in).
*From country to country the
local agriculture lends
fascinating individuality to the
landscape. Here the terraces are
no wider that a tractor and
create wonderful contour
patterns around the hillsides,
accentuated by a raking evening
light.*

Left: **Passing Palms, Tihama
Desert, Yemen** 20 × 15 cm
(6 × 8 in), *watercolour sketch.*

Above: **Dogs by a Bonfire, Somerset** *56 × 76 cm (22 × 30 in). In a flat landscape like this the distance is a low horizontal line broken by trees and the bonfire smoke.*

Opposite page: **The City Wall, Fes, Morocco** *42 × 59 cm (16¹/₂ × 23¹/₄ in). The greens in the foreground appear very much brighter than those in the distance which are shrouded by atmospheric haze.*

characterizes and identifies a certain place. I have many vivid memories of distinctive landscapes that I have travelled through – for example the Tihamah desert, which stretches along the Red Sea coast of Yemen. Here, squeezed into a taxi with a surprising number of other people, I was heading for the port of Hodeida. The heat of the desert was intense and the road ran straight to the horizon, with the miles of sand interrupted only by the occasional cluster of grass huts or a herd of camels.

A landscape like this can be very inspiring, either as something to note down in a sketchbook or, whenever time permits, to express directly in watercolour. Normally there are many possibilities for potential subjects, so that as well as considering the challenge of capturing an extensive stretch of landscape you could decide to choose a very limited view, or even concentrate on a single feature in the landscape.

When deciding exactly which part of a landscape to paint it is always helpful to

begin by spending a little time looking at and analysing the scene. Inevitably there will be some qualities or elements within the landscape that impress you more than others, perhaps the pattern of field shapes for example, as in *Island Terraces, Greece* (page 55), a particular stand of trees, or striking contrasts of light and shadows. Devise the composition of your painting so that it enhances these qualities. This will give the painting coherence and focus.

My approach to choosing a landscape subject is fairly intuitive, although it is also influenced by experience. But if you haven't painted many landscapes before, you may find it helpful to adopt a more planned method. This could include using a cardboard viewfinder as an aid to selecting

the best view. You can make a viewfinder as explained on page 34. Hold it up to one eye, and move it around to frame and compare different views.

While a landscape composition usually suits a rectangular or horizontal shape, it is worth bearing in mind that a portrait or square-shaped format can be equally

Above: **Tuscan View, Casole d'Elsa, Italy** *32 × 43 cm (12⅛ × 17 in). A sense of distance can be achieved by assessing the size and tone of distant features in relation to the near objects, such as the trees in the foreground.*

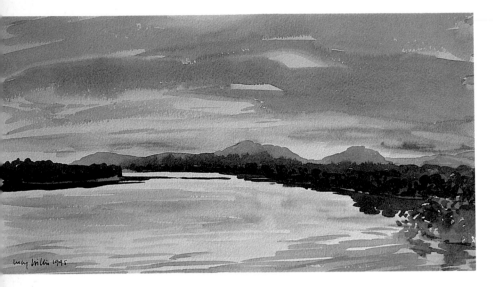

Distance

One of the biggest challenges in painting a landscape is how to condense an extensive view without losing sight of those features and elements that help to convey a feeling of space and recession. What is seen has to be simplified, yet at the same time the sense of distance must be maintained.

The handling of tone, colour, relative scale, texture and detail all play their part in suggesting depth, and this requires meticulous observation. I find it helps to paint what I see rather than what I know. For example, I may know that the distant hills are covered in fields and green trees, but my observation tells me they are bluish-mauve. Landscape painting is a matter of observing, understanding and interpreting.

So, when you want to create a sense of distance in a landscape painting, one of the

Above: ***Rufuji River, Sunset, Tanzania*** *21 × 38 cm (8¼ × 15 in). As the sun sets very quickly near the equator there were just a few minutes to catch the colours and tones of the sky, mirrored in the river, before I was working in the dark.*

effective sometimes. Also, another aspect of design that can add interest and impact is the position of the horizon line: whether you want a large expanse of land and less sky (as in *Island Terraces, Greece,* page 55) or vice versa, as I have chosen in *Dogs by a Bonfire* (page 56).

Right: ***Sunrise over Fes, Morocco*** *23 × 29 cm (9 × 11½ in). In hot countries it is always worth getting up early to catch the softness of a dawn sky, which all too quickly gives way to harsher sunlight.*

key things to notice is how the tone and intensity of a colour varies according to its distance from you. Objects in the background tend to look cooler in hue and weaker in tone than those close to you, as demonstrated in *Tuscan View* (page 57). Moreover, with foreground objects you see areas of light and dark tone, whereas with objects nearer the horizon the contrast between tones is softened, giving a lighter and more uniform tone.

This point is particularly relevant when your landscape includes large areas of green. A common mistake is to paint distant greens too warm in colour and strong in tone. Far-off hills and other features appear much bluer than they really

are; this is the effect of atmospheric haze on the light passing through it. Understanding this effect, known as aerial perspective, is an essential way of creating an impression of space and depth. This can be seen in *The City Wall, Fes* (page 57). Although there are trees and grass, no doubt, in the distance, the only area that registers green under these hazy conditions is the grassy slope in the foreground.

skies

Whether dramatic, with complex cloud formations, or simply a placid backdrop of weak cerulean blue, the sky is often an important element in a landscape painting: it influences colour and tonal values and

Above: **Meeting on the Shore, Dubai** *42 × 58 cm (16¹/₂ × 22¹/₄ in). I often leave the sky blank until the end of a painting. One reason for this is that if my water is dirty it is difficult to get a clear blue sky, so I leave it until I get home and can keep the colours pure. In this case it was just as well I hadn't put in the sky, because the man who owned the dhow in this painting approached as I was about to pack up and gave me a photograph of it with its red flag flying. Later, I was able to include the flag and work the blue sky around it, keeping the red nice and bright on the white paper rather than trying to overlay it on to an already-painted blue sky, which would have dulled the red.*

can determine the mood for the whole composition.

In any part of the world you will find an amazing variety of skies and while you will probably decide that in most of your watercolours the sky area, although significant, should play a subordinate role to the landscape features in front, in other paintings you may want to make it the principal area of interest, as in *Rufuji River, Sunset* (page 58). But the sky and landscape must always relate to each other, both with regard to how the paint is handled and, of course, the colour key. On a day when the sky is blue and the sun is shining, for example, the landscape will be bright with obvious shadows.

With a cloudy sky or a sunset the shapes and colours are changing all the time, so it is a matter of carefully observing what happens and then trying to capture the general character of the sky, rather than aiming for an exact representation. Also, look for different ways of suggesting distance and space. You will notice that in a clear blue sky the colour of the sky closest to you, the part that is immediately overhead, is much stronger than that towards the horizon. I like to use a graded wash of azure blue at the top of the sky, changing to cerulean and getting progressively lighter towards the horizon.

For most skies I like to work loosely, quickly and with one application of paint,

Below: **Under the Mango Tree, Zanzibar** *42 × 58 cm (16¹/₂ × 23 in). Shadows are very helpful for defining the plane of the foreground. It takes careful observation to sort out the shapes and patterns of random dappling like this, but if successful it will create a feeling of cool shade from which to look out at the brighter middle distance.*

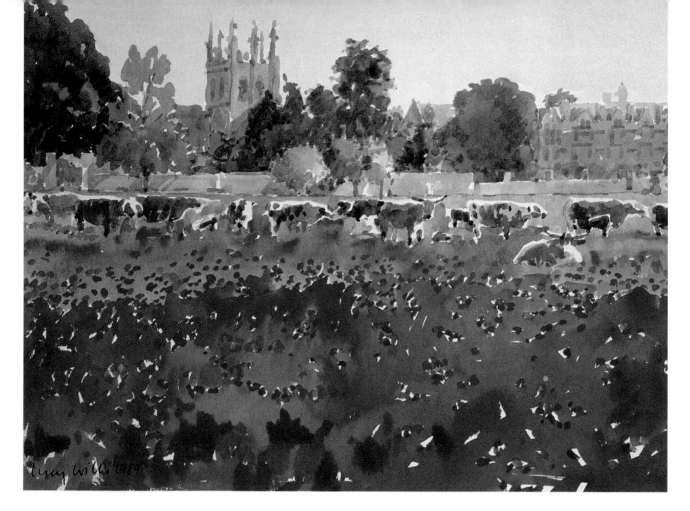

perhaps using several different techniques. So it is essential to have all the colours you need already mixed. Skies often combine very blurred passages, which could be painted wet-in-wet, with quite defined shapes, where a wet-on-dry approach is more suitable. Remember too that clouds often appear as bulky, three-dimensional forms rather than flat shapes. As such they will include shadows and reflected colour and light.

When I paint a landscape I very rarely start with the sky, and for closer views and other subjects painted on the spot, such as buildings and trees, I leave the sky area until last. The reason I do this is to avoid any of the sky wash showing through the shapes in front. Therefore, instead of superimposing or overlapping shapes on to

the painted sky area, I prefer to paint my subject first and then work round this with an appropriate colour for the sky. This enables me to keep the colours of my buildings and other objects as crisp and transparent as I wish.

Often, because the water is rather dirty at the end of a painting, if I want a clear blue sky, I will add the sky when I get home, sometimes weeks later, as I did with *Meeting on the Shore, Dubai* (page 59). I remembered what the sky was like and was aware that adding tone to a sky that up to then had been left white would have an effect on the rest of the painting. So I was careful to keep it subtle and light, so the figures in the shadow didn't become lost against the sky.

Above: **Christ Church Meadows, Oxford, England** *24 × 33 cm (9¹/₂ × 13 in). It is sometimes tempting to go into more detail in the foreground of a painting like this, but I try to keep the handling more or less the same throughout the picture and, if anything, looser as the ground gets nearer.*

Foregrounds

You might think the foreground area, because it deals with the part of the subject that is closest to you, is the section of the painting that should be treated in the most detail. However, it isn't necessary to work in this way and in my landscapes I quite often concentrate the main features of interest in the middle ground, leaving the foreground as a broadly treated space that leads into the painting. This could be an expanse of grass, for example, as in *Christ Church Meadows, Oxford* (page 61), or a ploughed field. To break up this area I make full use of any cast shadows or variations in colour. Sometimes, when I get my pictures home, I invent a cast shadow from a tree or building that could have been outside the picture area, just to help the foreground lead us into the picture.

Mood and Atmosphere

Successful landscape paintings are evocative: they convey a sense of place and a distinctive mood. Contrasting examples can be seen in *Tintern Abbey* (below), a heavy,

*Below: **Tintern Abbey, Wales** 51 × 66 cm (20 × 26 in). The sombre atmosphere of this view is due mainly to a close range of muted greys on the buildings combined with a similar range in the heavy, overcast sky.*

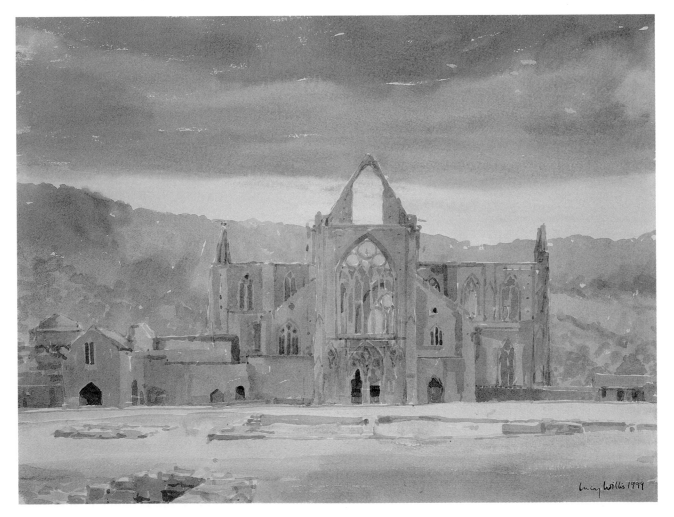

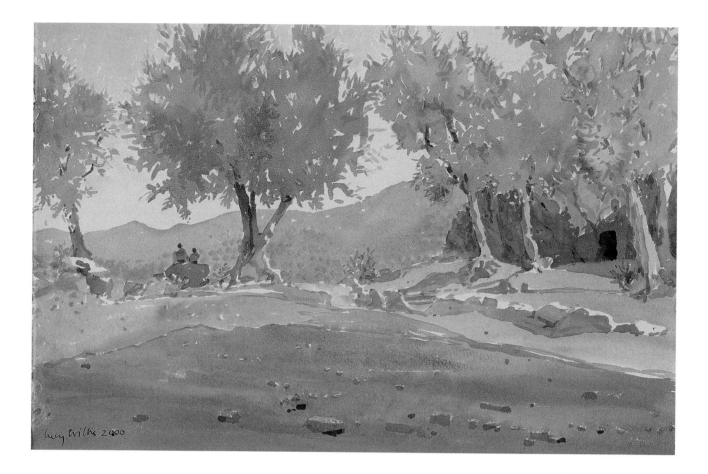

sombre scene, and *Olive Trees, Morocco* (above), which is sunny and calm. To create these qualities I rely mainly on capturing the effects of light and weather by building up the correct tonal structure and using the appropriate range of colours. However, I do not believe this has to be done in a self-conscious and deliberate way. If you are involved with the subject, look carefully, and paint what you see, the tones and the mood will develop automatically.

When the painting is finished, if you think there is something lacking, you can always enhance the sense of mood and atmosphere by deepening some of the tones to increase or reduce contrast. When I painted Tintern Abbey it was a dull and drizzly day with an uninspiring grey-white sky. I decided to make it more dramatic by darkening the clouds at

the top and allowing a warm glow at the bottom to throw the arch into sharper contrast. With Olive Trees, Morocco the air was clear and bright. Although the colours are still soft and muted, on the whole it is the strong shadows and yellow burst of reflected light on the right of the picture that suggest the atmosphere of warmth.

Above: **Olive Trees, Morocco**
42 × 58 cm (16¹/₂ × 22¹/₄ in).
I tried to achieve warmth by
using sharp tonal contrasts.

Below: **The Douro from above**
Oporto, Portugal *30 x 35 cm*
(12 x 13¹/₂ in). Evening sun on
water is particularly evocative of
peace and tranquillity.

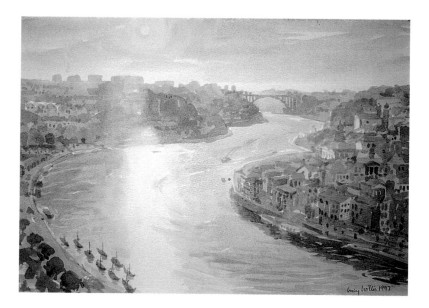

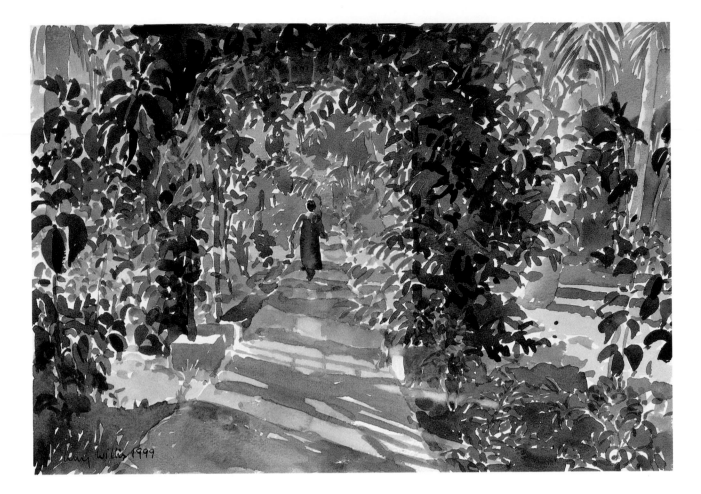

Gardens

When I am away from home, discovering a
quiet garden in which to paint makes a
welcome contrast to tackling more hectic
subjects in a crowded street or tourist
attraction, and I am always delighted at
the many possibilities for lively and
effective watercolours that gardens offer.
My own garden is a continuing source of
ideas and inspiration, and wherever I
travel I enjoy seeing and painting different
styles of gardens as well as the plants,
flowers, pots and so on particular to that
area of the world.

Whether it is a formally designed public
space in a town or city, part of the estate of
a country house or villa (like the Maharaja's
garden in *Walking in the Garden*, above), or
perhaps something far more individual and
intimate, a garden usually offers relative
calm. Many hotels have their own gardens
and you can also find small, peaceful and
often little-used gardens attached to
museums, galleries, churches and other
public buildings. In hot countries gardens
afford some shade, and when the weather is
not conducive to painting outside you can
often work from indoors or from a summer
house, conservatory or covered balcony.

Simplification

Gardens are full of interesting subjects to paint, whether as a broad vista or by focusing on a small area, such as a statue, fountain or pergola, or even an individual plant. Before deciding on the content of your painting my advice is to analyse carefully what it will involve, so that you are fully aware of how much you are taking on and how you are going to tackle it. For example, a lush garden that has a complexity of foliage, colours and shapes might be very pleasing to look at, but it will obviously need a good deal of skill and probably some simplification if it is to work pictorially. But don't be put off by difficult subjects. If you spend some time planning the composition, either in your mind or as a separate sketch, considering exactly what to put in and what to leave out, then there is no reason why you should not be successful.

Foliage

Here again success depends on simplifying what you see. A particular shrub or a line of trees is made up of many thousands of leaves and obviously it would be impossible (as well as unnecessary) to paint every one

*Below: **The Silver Garden, Hestercombe, Somerset, England** 51 × 66 cm (20 × 26 in). The colour of foliage can vary enormously. This Gertrude Jekyll garden has been planted with silvery plants throughout, making a harmony of blues and greys with very few strident areas of green.*

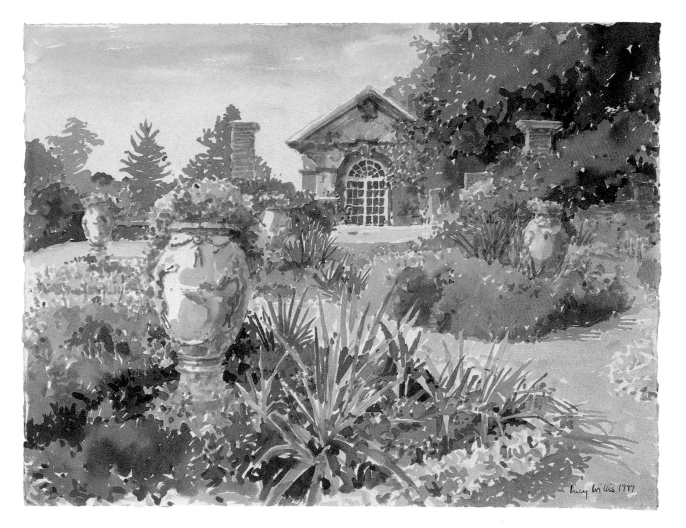

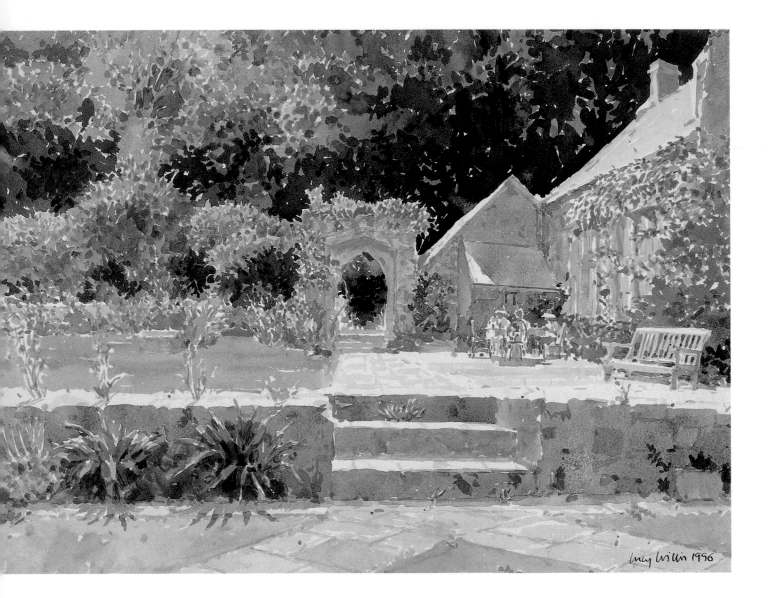

Above: **Lunch in the Garden,**
Somerset *56 × 75 cm*
(22 × 29¹/₂ in). English gardens
such as this abound with green,
and it is important to try to make
some sense of it all without
letting the painting become
monotonous. Half-closing your
eyes to clarify the tones is a great
help when trying to simplify the
confusion of shapes and closely
related colours.

of these. So you must rely on techniques that produce a convincing impression of foliage. Start by looking at the mass of foliage through half-closed eyes to assess the main blocks of tone. Some parts of the foliage may be sunlit and filigree in character while others are dense and dark in tone, as in *Lunch in the Garden* (above).

Express these general tones as broken or solid washes, painting wet-in-wet or with graded or flat patches of colour, as appropriate. For an open-structured shrub or tree I will leave white flecks of paper showing within the washes, if necessary working the background colour into these later, or I will consider both the positive (foliage) shapes and the negative (background) spaces together. I always try not to paint foliage over a background wash because this kills the freshness of the

colours. It is also important to pay close attention to the outline of close-up or middle-distance foliage where the use of more deliberate marks helps suggest the particular type and shape of leaves. In contrast, very distant trees will appear quite even in tone and texture, and far less defined in outline.

Foliage is at its most translucent when the sun is behind it and something that helps create some very interesting compositional and tonal effects is to choose a viewpoint that involves looking into the sun, an approach known as contre-jour (literally, 'against the day'). Such a viewpoint automatically simplifies the subject, showing distant features in silhouette but at the same time producing a 'halo' effect where the light catches the outlines, as in *Lunch in the Garden* (left). I particularly love the hot vibrancy of leaves with the sun shining through them, especially when set against a shadowy area of cooler, darker colour, as in *Yellow Tree, Senegal* (right).

Flowers

As with foliage, colourful flower borders work best if treated in broad terms, carefully choosing a method of applying the paint to suit the types of flowers being considered. For distant masses of flowers you can use simple marks of colour,

painting almost abstract shapes yet with just enough definition to suggest the different varieties. Try contrasting this approach with one or two more specific, close-up flowers in the foreground shown in greater detail. Resist the temptation to become fiddly in the close-ups: keep the marks as broad as those in the distance but apply them to a larger flower.

One of the main problems when painting flower gardens is creating a feeling of space and so distinguishing between the flowers and their background. Study carefully the

Below: **Yellow Tree, Senegal**
45 × 34 cm (17¹/₄ × 13¹/₂ in).
I particularly like the effect of sunlight shining through foliage. If you can find a view where the leaves are set against a darker background, they glow all the more.

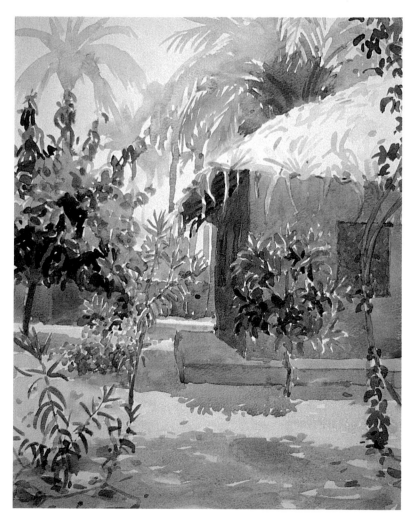

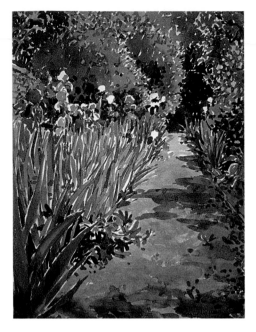

Right: **Garden Path with Irises, England** *45 × 35 cm (17¹/₄ × 13¹/₄ in). There is a spectrum of leaf shapes here, from the clearly drawn individual iris leaves to the far trees and bushes, where the detail is much more generalized.*

Below: **Summer Garden, Northamptonshire, England** *41 × 59 cm (16 × 23¹/₄ in). I composed this painting with close-up foliage from the tree above and its shadow below in order to frame the house and give the impression of looking across a bosky garden.*

Below right: **Sweeping Leaves, Greece** *21 × 15 cm (8¹/₄ × 6 in), pen study.*

lights and darks within the subject and make full use of tonal contrast to define shapes. Notice how in *Garden Path with Irises* (above) for example, the flowers are picked out as light shapes against the dark foliage of the background while,

contrastingly, their leaves are dark against light. For a painting like this I start by making a few subtle marks with my brush to indicate where the flowers will be, then I create their actual shapes by blocking in the negative areas behind.

Something else that can create difficulties is dealing with an uneventful foreground area in a garden, such as an expanse of grass, gravel or patio. It isn't always necessary to have a busy foreground of course, and as in *Lunch in the Garden* it can be effective to leave an open, restful space that leads into the picture. Alternatively, dappled shadows are a useful means of adding interest (as for instance in *Summer Garden*, below left) and sometimes I will put down a rug on a lawn or introduce a pot plant to a foreground if I think the composition needs it.

As well as general garden views you can also make studies of individual flowers. I

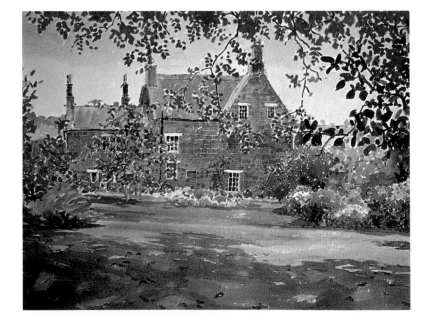

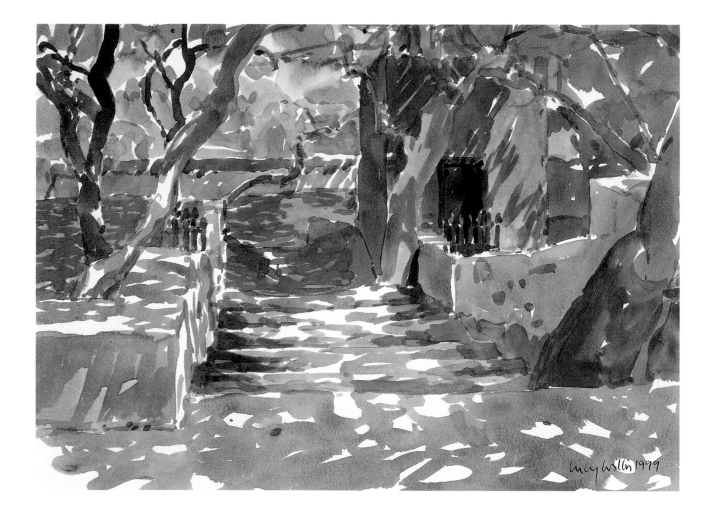

often work on the spot in this way, particularly in my own garden, and I find the experience of having painted flowers there, and in many still lifes in my studio, is a great asset. The knowledge gained of different leaf and petal shapes and the time spent noticing proportions and essential characteristics helps me work with confidence and speed when I try similar subjects on my travels. Such studies will require some accurate drawing, which I usually do directly with a brush, and as in all my paintings the aim is to capture the subject by the most economical means. Freshness and spontaneity are more important, I think, than botanical detail.

Greens

The secret to using greens successfully in a garden painting is to notice the enormous variety you will almost certainly encounter wherever there is enough water to make things lush. Greens change radically according to the light. In bright light, with the sun shining through the foliage, a green can look a hot, acid yellow in colour,

Above: **Garden Steps, Greece** *28 × 38 cm (11 × 15 in). One of the reasons I enjoy painting in Greece in summer is the selection of warm, dusty colours that result when the spring greenery dies off in the heat.*

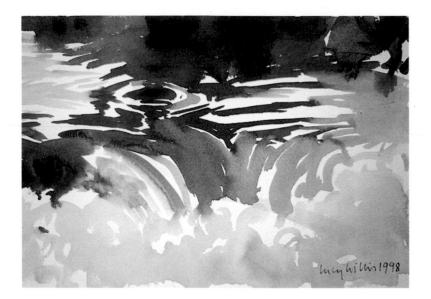

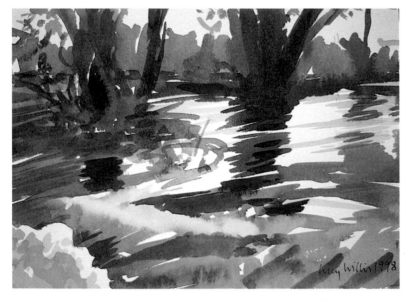

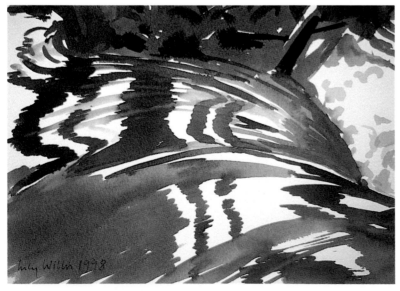

whereas in other parts of a garden the greens might reflect colour from the sky and therefore be blue-green, or they could be in deep shadow and so appear almost black. Similarly there are contrasts between translucency and opaqueness. There is a huge range of greens and in my palette I have a double pan of sap green that I use sometimes on its own but more often mixed with yellow, a little cerulean, Prussian blue or Winsor violet, as the basis for making a useful variety of greens.

One of the joys of travel is to find gardens in hot countries where the ground is parched and the colour combinations are therefore refreshingly different for an English painter. *Garden Steps, Greece* (page 69), for example, has only stone and dried pine needles underfoot, with the green limited to a mere hint in the distance.

Water

Water is exciting to paint, whatever its form, mood or character, but it can also seem daunting. The main problem is how to capture the feeling that water is transparent yet at the same time full of reflected shapes and colours. And a further complication is that it is often moving. Water may be rippling in the wind, tumbling over rocks in a stream or crashing against the shore in the form of waves. So can transparency,

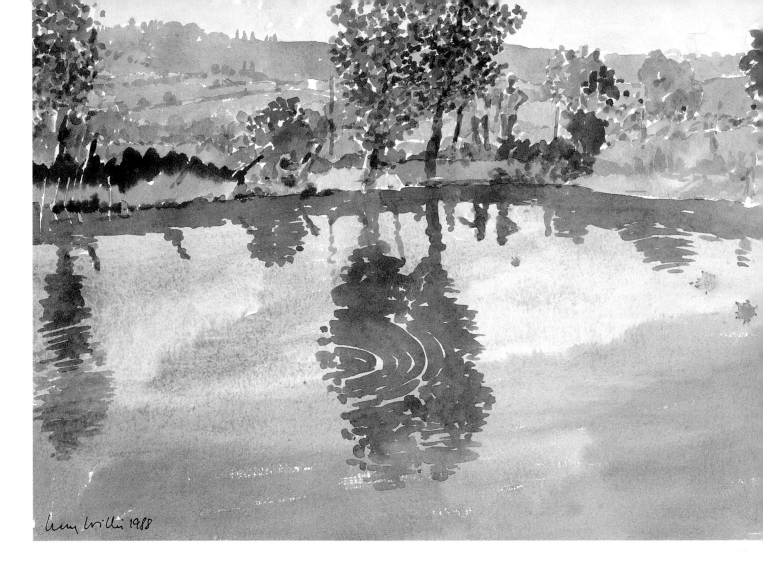

(signature) *Hazel Soan 1988*

reflections and movement all be conveyed with the economical use of watercolour?

They can, provided you are observant, try to understand and analyse exactly what is happening, and are prepared to simplify what you see. The key point to bear in mind when painting water is that, because it is colourless and transparent, its particular characteristics and qualities are determined by everything around it. Water is influenced by the light and the sky, and it draws its colour from the various forms reflected in it. I live beside a tidal river and I look at it almost daily from my window or on a walk along the bank. I never cease to

be amazed at the variation in colour, surface and reflection, and this changes from day to day and season to season. By analysing the way it looks I build up an understanding that I can call upon when I come to paint water on my travels.

Reflections

Essentially painting water is painting reflections. I begin by looking at the main shapes and tones of the water and then I consider the colours reflected in it, which normally are not quite the same as those of the actual objects. The reflected colours are slightly darker (since the water cannot

Above: **The Frog Pond, Italy**
*35 × 45 cm (13¹/₄ × 17¹/₄ in).
It is where something dark is
reflected, in this case the tree,
that you tend to see the actual
colour of the water.*

Opposite page, top to bottom:
Tone Study 1
Tone Study 2
Tone Study 3
*all 28 × 38 cm (11 × 15 in).
I did these watercolours at
home from pencil sketches made
along a stretch of the river
where I grew up, coincidentally
called the River Tone.*

reflect all the light falling on it) and of a more limited range, like the tree in *The Frog Pond, Italy* (page 71). With this assessment of shapes, tones and colours in mind I start work on applying the paint, having already mixed the range of washes I think I will need. What is particularly important is to look at the edge of each reflection, for it is the nature of these edges – whether they are broken, meandering or clearly defined – that expresses moving or still water.

The surface of the water is more or less invisible. Consequently, unless there are leaves or other objects floating on the surface you won't need to consider it as something separate from the rest. If you capture the reflections correctly, the surface will automatically look right. Moving water usually has a certain repetition. Observe and analyse this so that you can simplify the surface into the main areas of light and dark. You will notice that in moving water,

Below: **Birds in the Boulong, Senegal** *35 × 45 cm (13¹/₄ × 17¹/₄ in). I was amazed by the number of exotic birds that appeared, undisturbed by my presence. I painted them silhouetted against the bright surface of the water.*

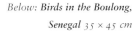

in a river for instance (see *Tone Studies* on page 70) the reflections are broken in outline and somewhat distorted, whereas in calm water they can appear as an almost exact mirror image. This is so in *Birds in the Boulong* (left).

But whatever the type of reflection, try to express it as a coloured shape with its outline defined by a change of tone. And

think carefully about which techniques will be the most appropriate. You may have to work quickly, though this need not hamper the degree of control and, as always, my advice is to avoid too many washes. In *Pulteney Bridge* (above), however, I painted the whole dark reflection in one continuous wash of brown to start with and then worked back into it with the very dark

reflected arches when this was dry, leaving flecks of the first wash showing through.

One of my favourite subjects involving water is the beach just after high tide, when the wet sand reflects the sky and the figures above it. In fact, with the sea as a constantly changing backdrop, the beach offers a wonderful variety of interesting subjects to paint and, as long as one can

Above: ***Pulteney Bridge, Bath, England*** *41 × 59 cm (16 × 23¼ in). The reflection of the bridge was mainly achieved in one dark wash. This was overlaid with a second, darker one when the first was completely dry.*

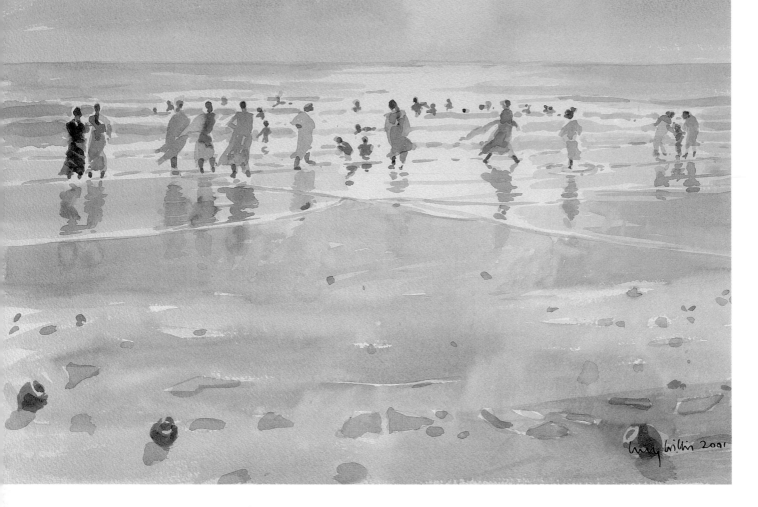

Above: ***A Warm Wind,***
Bombay *33 × 46 cm (13 × 18 in).*
Receding waves leave a shining
sheet of water on the sand that
catches the reflections of walking
figures. Sketchbook studies for the
painting are shown right.

find a shady spot, it is possible to stay all
day and work on a series of paintings.

Another approach is to take a
sketchbook to the beach and make studies
that can be translated into watercolour
later. This is how I worked for the painting

above and also for the Greek beach scene
on page 110. Once I had the figures in
position I could suggest the wet reflective
sand with just a few carefully arranged
colours and tones.

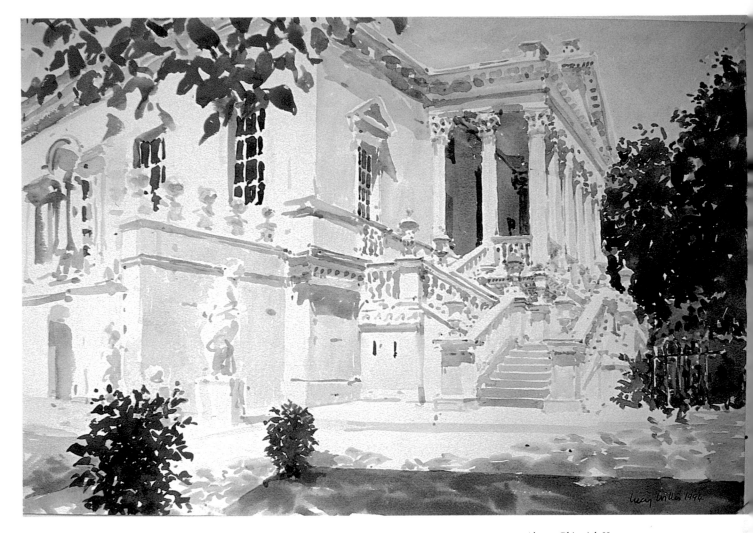

Towns and Buildings

Despite the increasing number of rather similar-looking modern buildings that are appearing in every part of the world, fortunately there are still plenty that show the local character and style. And in some countries of course, especially in their more remote areas, the towns and villages look just as they always have done, untouched by the influence of the modern world. In my travels I have encountered a wealth of architectural styles and wherever I go I find plenty of exciting subjects.

What particularly interests me is the way in which different people around the world construct and decorate their buildings. I like to spend time standing and analysing these aspects of the architecture, for in this way I gain a much deeper understanding of a place and its inhabitants than I would from simply walking the streets in wonder.

Above: **Chiswick House, England** *41 × 59 cm (16 × 23¼ in). Looking up at this Palladian edifice from ground level creates steep angles and pronounced perspective.*

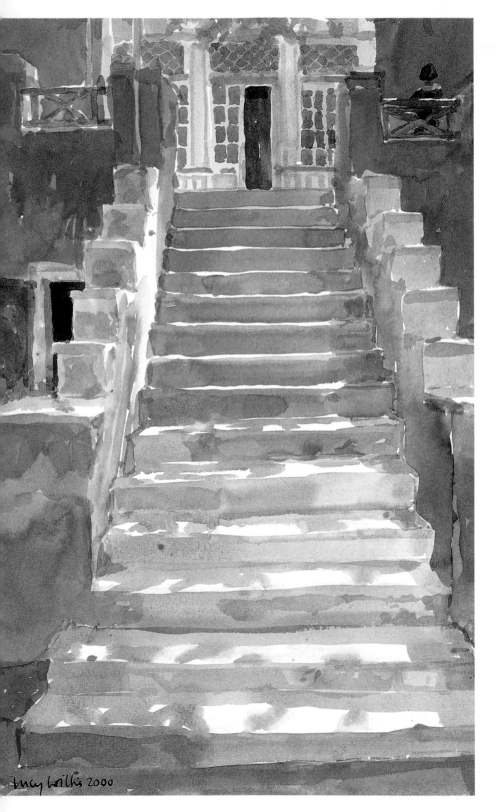

lucy willis 2000

Buildings do not necessarily have to be exotic palaces or important heritage sites to make good subjects to paint. Naturally the possibilities include impressive architecture of this type, but something far less imposing can be just as challenging and interesting. For example, a humble façade or group of buildings can be enlivened by a certain quality of light, so creating exciting patterns of light and shadow while enhancing the architectural features, different surfaces, and so on. Sometimes at dusk a quite ordinary house can take on a mysterious air when lit from within, as in *Warm Night, Saumur* (right). Other possibilities include painting a more general view, perhaps from a balcony or a distant vantage point, as in *Darricha* (page 36), or contrastingly, making studies of individual architectural features, such as windows and doorways.

Urban environments are usually bustling with activity and so (more than in any other location) practical considerations can play a vital part in determining exactly which viewpoint you can choose and how much time you can spend on a painting. Generally it is a matter of finding a painting spot where you won't be in anyone else's way and, in hot countries, one that is in the shade. A crowded street imposes the most limitations, but in a large, public space there will be more scope both for selecting an interesting viewpoint and for getting far

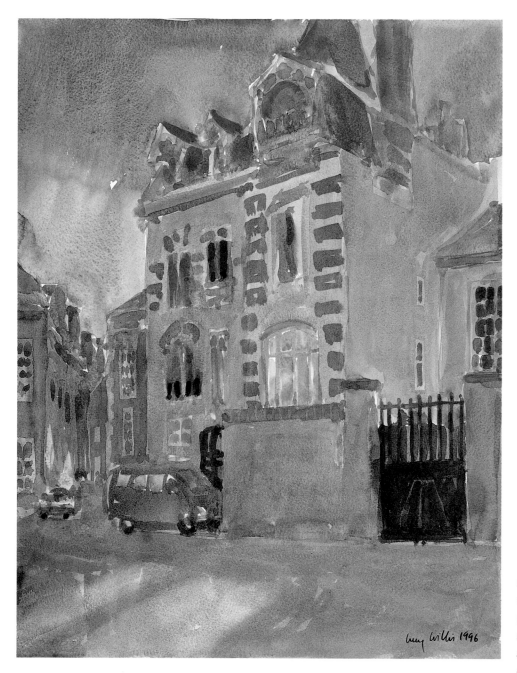

enough away from the subject matter to see it clearly and be able to assess angles and relative proportions accurately.

With *The City Palace, Udaipur* (page 78), for example – an elegant building made all the more impressive by the play of light and shadows – there was plenty of space in front of the building for me to find a good place to settle down and paint, so I was able to spend the whole morning there and tackle a large watercolour. In contrast, for *Jaisalmer* (page 79), I was in a narrow street and had to be much nearer, with a front-on view of the building, although fortunately there was a raised platform opposite that I could sit on, out of the way of traffic. Where circumstances are more difficult I usually keep to smaller paintings or, if I

Opposite page: **Syros Steps, Greece** *52 × 35 cm (20¹/₂ × 13¹/₄ in). The subject of this painting is not so much the steps but the shadows that play on them and the patches of reflected light that create the glowing pinks and oranges.*

Above: **Warm Night, Saumur, France** *41 × 30 cm (16 × 12 in). One of my favourite times to paint is when the yellow electric lights come on in the evening but the sky still retains its blue, making a combination of warm and cool colours.*

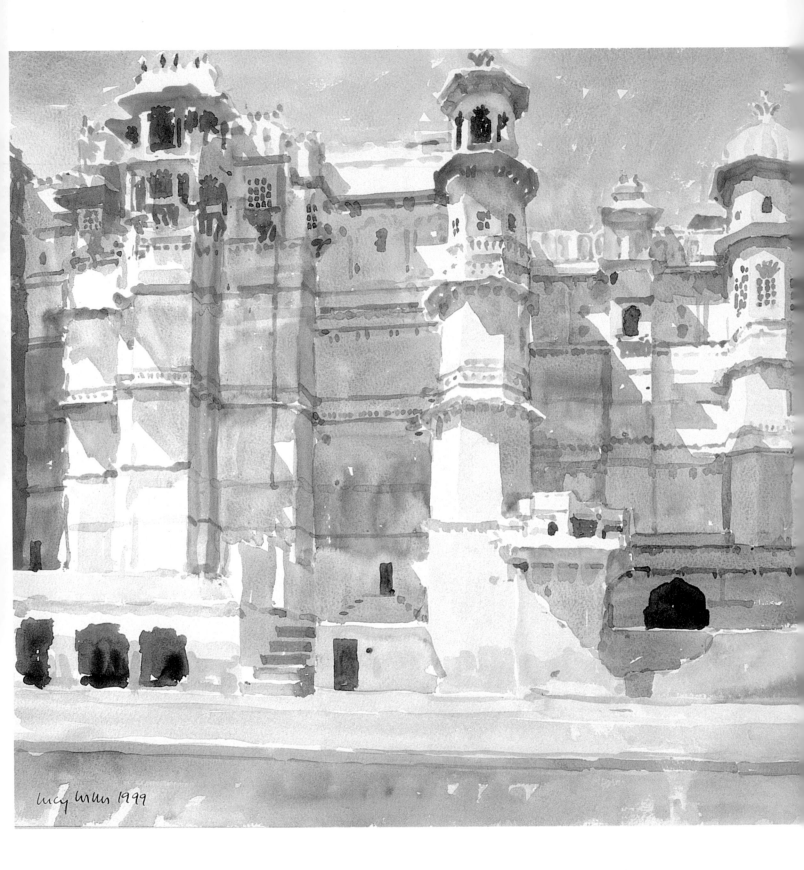

Lucy Willis 1999

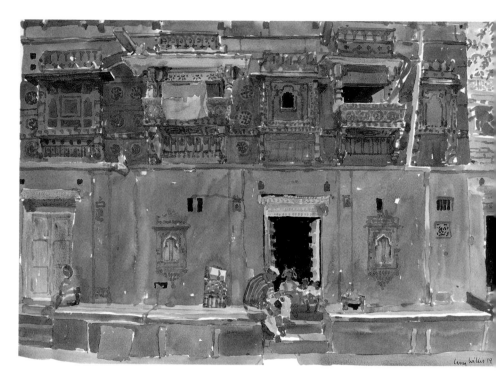

think it will be impossible to work in watercolour, I will make a sketch or take a photograph. But these occasions are rare and my preference is to paint directly in watercolour as much as I can. There are usually plenty of alternatives if you find that a particular building or location isn't very suitable.

Planning and Perspective

In narrow streets the nearness of buildings can be a problem and you will need a sound understanding of perspective to cope with the distortions of the various planes and angles caused by the accentuated foreshortening of the view. With close-up

*Above: **Jaisalmer, India** 41 × 59 cm (16 × 23¼ in). For me the beauty of much Indian architectural decoration lies in the contrasting areas of elaborate surface detail and those of calm, patinated stone.*

*Opposite page: **City Palace, Udaipur, India** 41 × 59 cm (16 × 23¼ in). The structure of this magnificent white building is drawn largely with the shapes and colours of the shadows.*

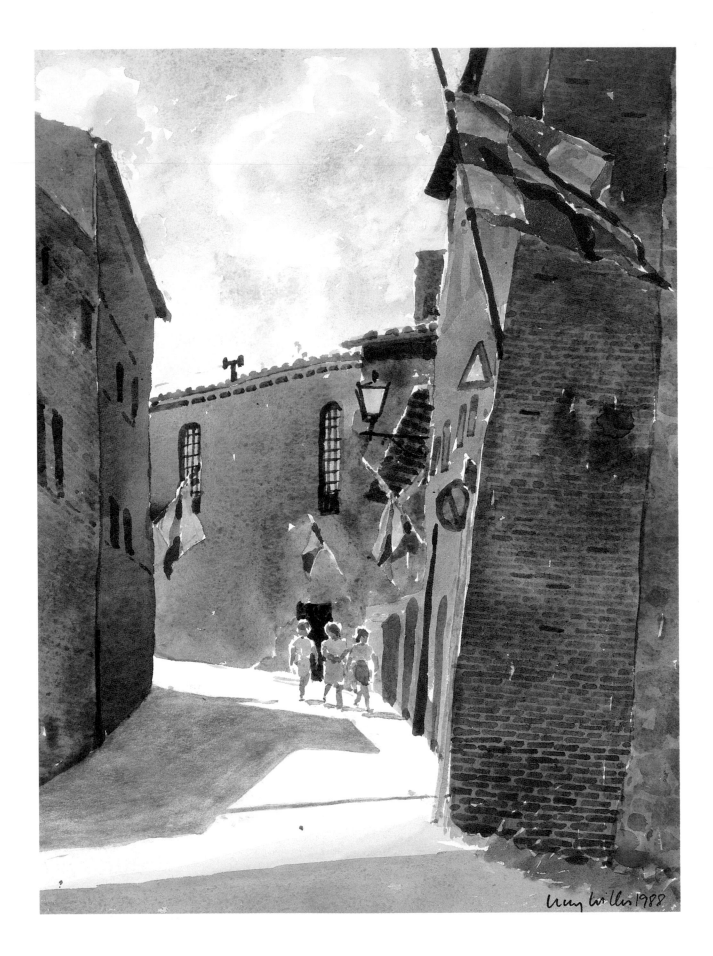

buildings seen from the side the perspective is steeper and the angles acute. When making the initial drawing there are two aspects in particular that must be checked carefully. First are the vertical lines which, if you are working at a board flat on your knee, might inadvertently be drawn with some divergence. Use your paintbrush as a measuring device to check these. Measure the distance of the top of the vertical line from the edge of your paper, and likewise the bottom of the line. These should be the same if you want a true vertical, although old buildings are often rickety and a certain amount of wobble can look better than too rigid a framework, as in *Three Girls of Casole d'Elsa* (left).

The second thing to check is the angles of the roof and of the base of the building. Unless you are looking at the building head on, these angles will converge to meet at a vanishing point on the horizon. Depending on your viewpoint, your painting could involve one, two or several vanishing points and it is likely that these will be outside the picture area. Be alert to these considerations and make comparisons between one angle and another as well as the relative proportions and positions of different parts of the building – windows, doors, chimneys and so on – to help you draw it convincingly. With practice this type of approach becomes automatic.

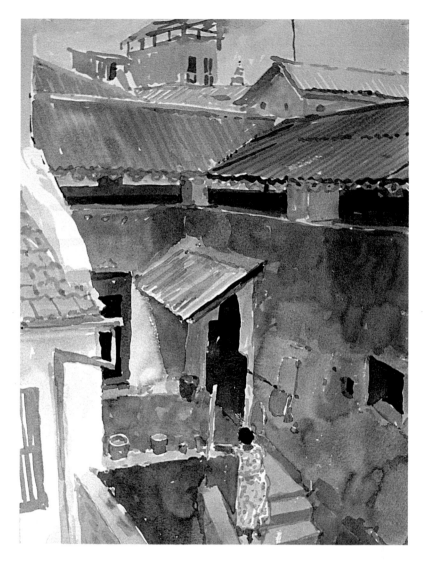

I often take a little more time over the initial stages when painting an architectural subject because it is important to ensure that everything will fit on to the paper, is spaced correctly, and that the proportions are sound. Once a painting is fully under way it is more difficult to make radical changes, so a wrong shape or angle can look even more obvious. Something I usually do is check my eye level in relation to the subject when tricky perspective is

*Above: **Zanzibar Pink** 41 × 30 cm (16 × 12 in). Old plaster in tropical, humid countries takes on a richness of surface texture. I painted this from a sheltered rooftop after a torrential downpour.*

*Opposite page: **Three Girls of Casole d'Elsa, Italy** 41 × 30 cm (16 × 12 in). The girls who walked into view as I painted these buildings gave me a fortuitous way of giving scale to the towering walls around them.*

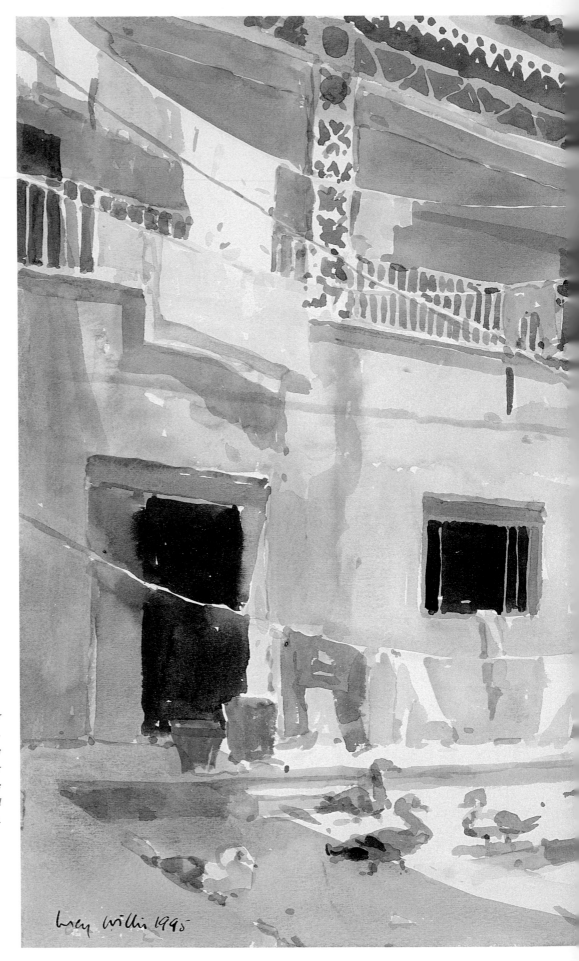

Right: **Courtyard, Zanzibar**
41 × 59 cm (16 × 23 1/4 in).
The shadow cast across the
courtyard and the deep tones under
the walkways help to define the
space and three-dimensional
structure of the scene.

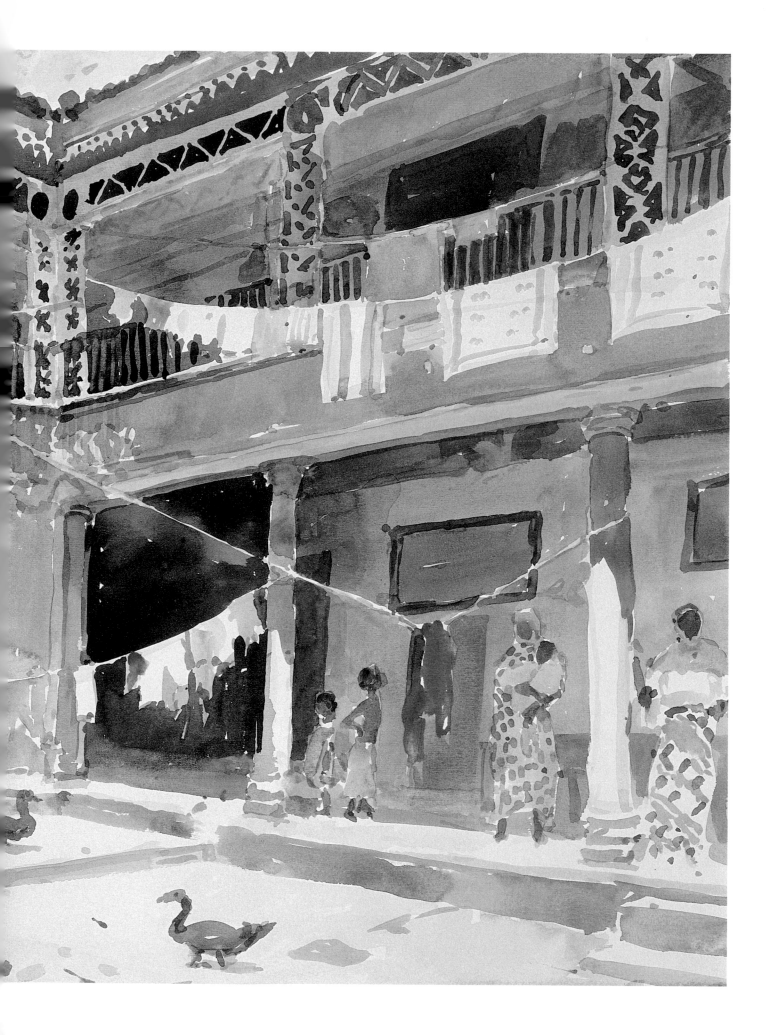

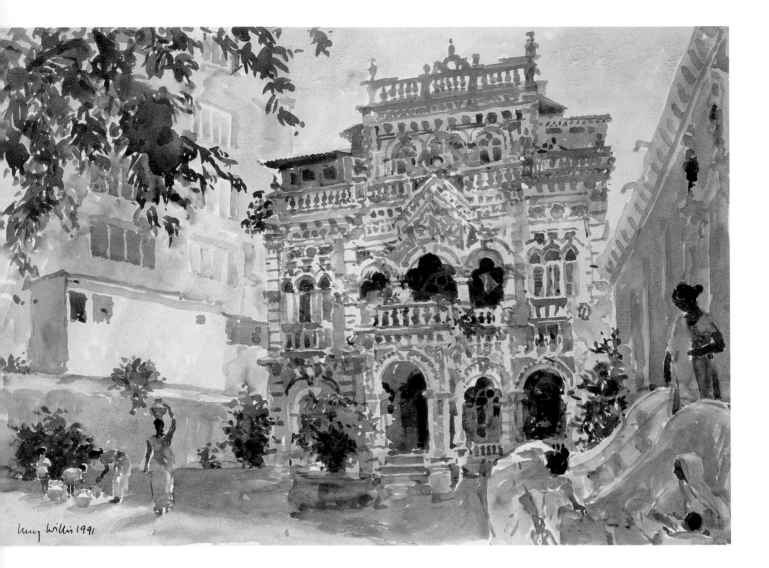

Luy Willi 1991

Above: **House on the Hill, Bombay, India** *41 × 60 cm (16 × 23½ in). I tried to suggest the extraordinary ornateness of the central building without getting bogged down with the accuracy of every detail.*

involved. If you hold a pencil or paintbrush horizontally at arm's length and level with your eyes you can estimate where that horizontal line intersects the building in front of you. It may, for example, be level with the bottom row of windows if you are working from ground level. You can then use this as a 'key' from which to develop the basic plotting of your perspective, and your vanishing points will theoretically fall on it, even if they are out of the picture. A good understanding of perspective is essential when you set out to paint architecture.

Shadows, Textures and Details

What is also useful in the initial stages is an assessment of the tones, because if these are right then the whole building will look solid and three-dimensional. Half close your eyes

to help you judge the lightest, mid-toned and darkest areas. Remember that once you have decided on the position of the shadows and fixed the moment in time, as it were, then you must keep to this. I'm always attracted to subjects that have interesting contrasts of light and dark. In *City Palace, Udaipur* (page 78), for instance, the whole project was concerned with painting shadows. Because it is a white building the shadows are more important than ever. They are the principal means of defining its shape and form as well as providing a wonderful interplay of gentle colour and reflected light.

Some architectural subjects are extremely decorative and elaborate. My advice is: don't be put off by this. I never avoid a subject just because it looks too complicated. If there is something lively and exciting to paint, then I'll try it. Having carefully thought about the composition of the painting and the mass and form of the buildings, it then becomes a question of deciding how much detail to include as the watercolour progresses. Usually there are some features that are individual to the building and consequently these have to be included in the painting in order to convey its identity and character. In contrast, there will be other details that can be suggested, simplified or ignored. As with all paintings, you have to decide what it is that is important about the subject: what do you want to say about it?

Left and below: **Shuttering, Nizwa, Oman** *56 × 76 cm (22 × 30 in). Having marked the basic shapes and proportions of the buildings, I mapped in the broader planes with washes in a variety of mud colours. Building up the details and contrasts as I went along, I ended by adding an extra building behind the central arch to enhance the composition.*

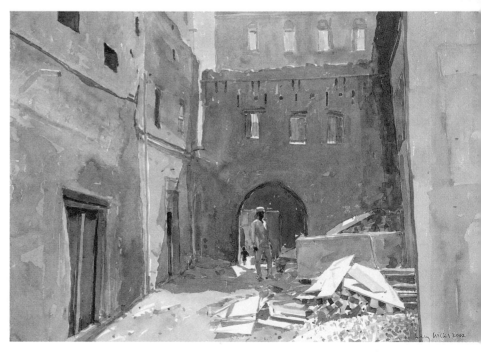

If you look at *House on the Hill, Bombay* (page 84) for example, you will see that, rather than getting involved with every little curlicue and detail, I have created the impression of the building being highly decorated by using dots, dabs and squiggles of colour. Always with this kind of subject it is necessary to decide which parts you are going to generalize and which parts need to be more specific. A similar, quite loose approach is useful for suggesting different textures on a building. Depending on the subject, I might apply several wet washes,

which I will let run together, to give an impression of the texture, as I have done in *Zanzibar Pink* (page 81).

My palette for painting architectural subjects is essentially the one I always use except that I may add one or two bright colours, such as a bright turquoise, specifically for the colourful architectural details that I may come across in the Mediterranean and the Far East. Shutters, doors and even whole houses can sometimes be very colourful. I occasionally also use the wax-resist

Below: **Evening at the Taj, Bombay, India** *41 × 60 cm (16 × 23¹/₂ in). The reflective marble surfaces and garden beyond made an interesting composition and a tranquil retreat from the busy streets.*

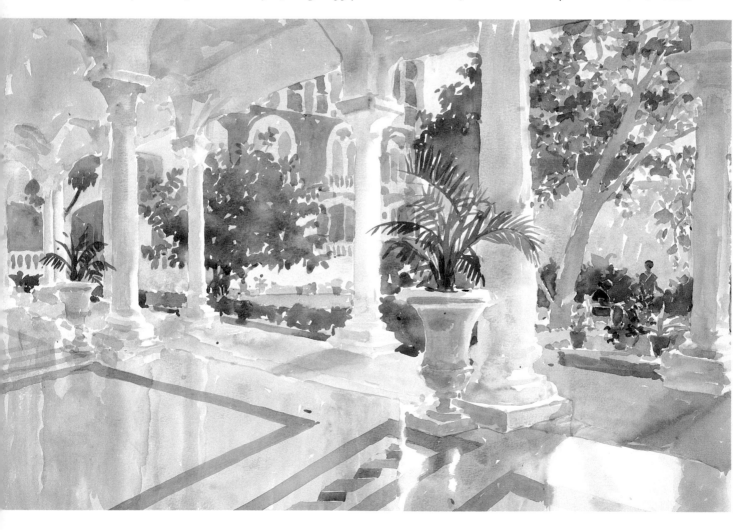

technique described on page 18 for *The Red Bicycle* (page 42), where I drew the white decoration around the door with the end of a candle before washing the whole wall with strong yellow ochre.

Interiors and Still Life

With such a wide choice of exciting subjects to paint outdoors you might be forgiven for thinking that interiors and still lifes are not the best option when you are travelling, but in fact they can provide an interesting alternative source of ideas. When you want to escape from the heat or other uncomfortable weather conditions, or you would simply like a change from landscapes or architectural subjects, you will find plenty of suitable things to paint in the quieter and more comfortable surroundings of an interior. After a day painting on the busy streets of Bombay I was more than happy to spend a few quiet hours in the colonnaded bar of my hotel to paint the marble surfaces and the gardens beyond, which you can see in *Evening at the Taj, Bombay* (left).

Normally, one of the advantages of being inside is that you can spend whatever amount of time you need on your painting. There is less likely to be the same urgency to finish as there is when painting outside, so you can

adopt a more relaxed approach and, if you think it necessary, devote several sessions to working on your subject. Often the lighting is also less of a problem. When there is bright sunlight streaming in through a window, as in *Blue Doors, Greece* (above), you will need to fix your shadows and the distribution of lights and darks as quickly as possible, just as when working outdoors. But if the room is illuminated by diffused or artificial light, like

*Above: **Blue Doors, Greece**
56 × 38 cm (22 × 15 in).
Working indoors, looking out,
has many attractions – not least
being that it is a cool place to
work out of the sun.*

viewpoint and composition are essentially one and the same thing.

If you haven't painted interiors before then it is probably best not to be too ambitious at first. So start with a section of a room or an individual feature, such as the open window in *The Killa Bhavan* (below), rather than a wide-angle view of the whole room. There may be potential painting subjects in your hotel or holiday cottage, or you may find other ideas in local churches, museums, palaces and the like. Look for a quiet corner where you will be away from the flow of visitors and check whether you need permission to paint there.

Most of these points apply equally to still-life painting. You might come across a

*Above: **Yellow Lampshade, Cornwall, England** 66 × 65 cm (26 × 25¹/₂ in). This painting presents a very different aspect of a seaside holiday from the blustery beach scenes I'd been painting during the day.*

*Right: **The Killa Bhavan, Jaisalmer, India** 33 × 25 cm (13 × 10 in). A small study in colour and tone inspired by the interior of a tiny guesthouse.*

*Opposite page: **Blue Chairs, Greece** 41 × 30 cm (16 × 12 in). Tables and chairs present ready-made compositions.*

Yellow Lampshade (above), the tonal values will remain constant. Observing the particular quality and influence of light is very important for creating the mood and atmosphere of the scene.

Selecting Ideas

As in all my work I prefer to paint interiors 'as found'. I will sometimes simplify what is there but I don't usually make any significant alterations to the arrangement or composition of the view that I have chosen to paint. For me, composition is intrinsically linked to the selection process, so that

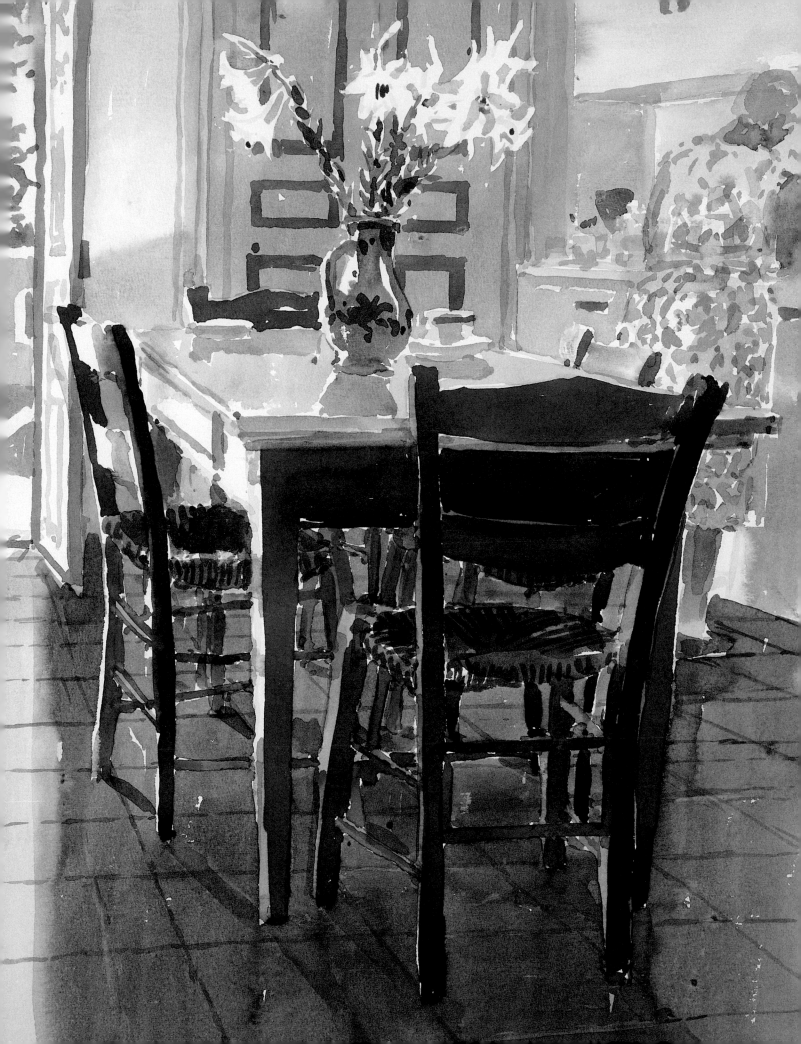

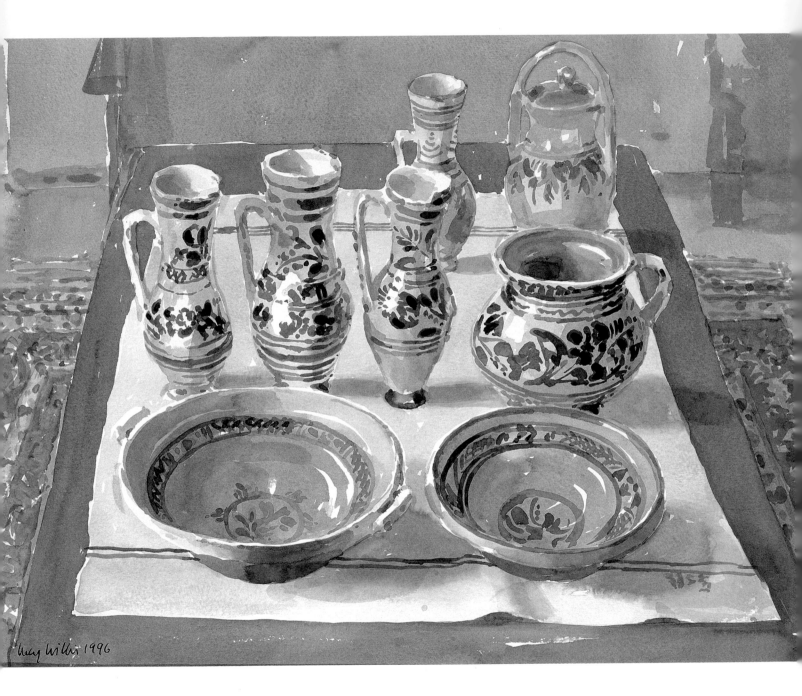

Lucy Willis 1996

ready-made still life, like *The Dining Table* (below), or you could set up your own in the room where you are staying, as I did for *Transylvanian Pots* (left), where I quite simply wanted to record my Hungarian host's collection of traditional pottery. I try to place things in a way that doesn't look too contrived or deliberately 'artistic' and in this case I just placed the pots and bowls in ranks on a low table so I could get a good view of the decorative patterns. Not only is this is a useful type of subject matter to consider when the weather has ruled out other options but also, if you choose the right objects, such paintings can say something significant about the culture and activities of the country or locality in which you are staying.

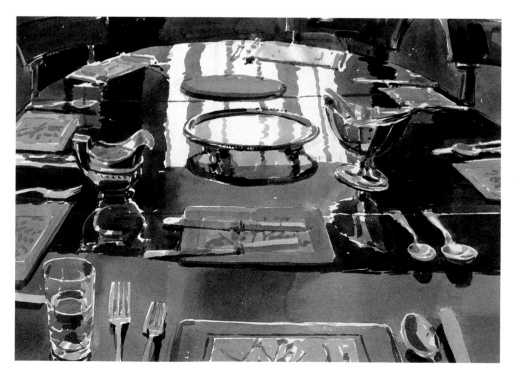

Above: **Guernsey Picnic, Channel Islands** *38 × 56 cm (15 × 22 in). Commissioned by the Guernsey tourist board to depict the island in a series of watercolours, I realized on a rainy day that my brief could also include the local produce.*

Opposite page: **Transylvania Pots, Hungary** *38 × 56 cm (15 × 22 in). These pots, collected over years, held great significance for my Transylvanian hosts.*

Left: **The Dining Table, England** *25 × 38 cm (10 × 15 in). I enjoy the challenge of disentangling objects and reflections in this kind of still life, although it may have to be done with some haste if a meal is about to begin.*

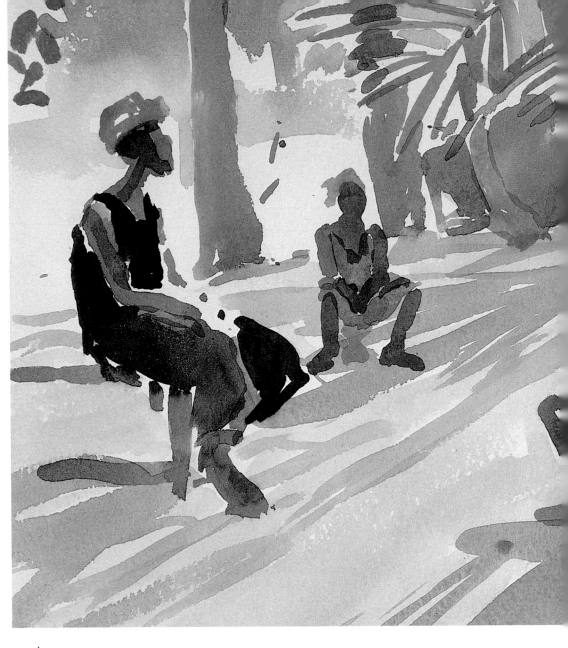

Figures

The different characters, poses, costumes and activities you come across when you are travelling are interesting to paint, either as individual studies or as part of a larger composition. Often, incorporating figures into a painting will add to its vitality and, seen in a particular context, figures help to convey a strong sense of place. Also, as in my painting of *The Three Girls of Casole d'Elsa* (page 80), figures can give an indication of the scale of a scene. In this painting, without the relatively small figures walking down the hill, the buildings would appear much less imposing. You can take enormous liberties with figures in a painting, placing and composing them as you wish, and their clothes can provide a way of introducing some colour (as in *Remembering Bhuj*, page 99).

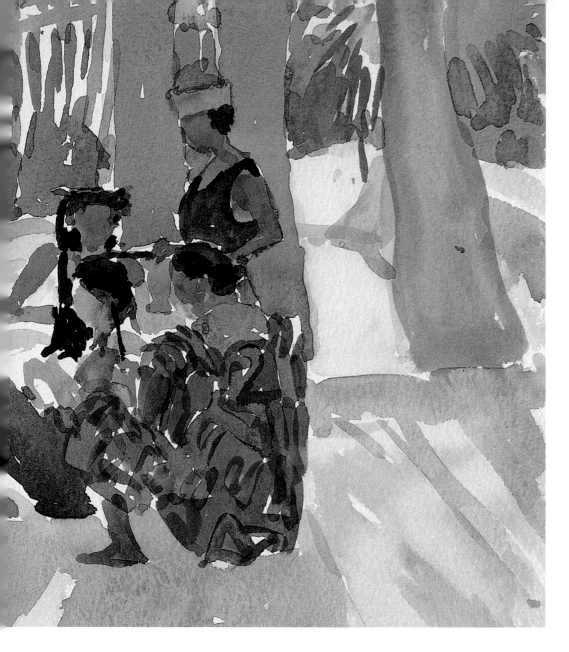

Left: **Les Tresses, Senegal, West Africa** 25 × 38 cm (10 × 15 in). My daughter having her hair plaited gave a number of people the excuse to hold more or less the same positions for fairly long periods of time, enough for me to do a couple of studies like this.

Below: **Bhaijibhai, Madhya Pradesh, India** 38 × 25 cm (15 × 10 in). While this man unfolded the sad story of his displacement by the building of a dam in India I tried to capture his likeness from several viewpoints as he shifted positions.

Opposite page: **Indian Dancing Girl**, pen drawings from a sketchbook 20 x 15 cm (6 x 8 in)

studies and Portraits

Some artists are reluctant to try figure painting. It is true that this is a difficult discipline, but with plenty of observation and practice the necessary skills can soon be developed. The key factor lies in learning how to simplify the figure, so that you can work quickly and confidently with a few basic shapes, tones and colours to interpret a certain stance, convey an impression of movement, and so on.

Any practice and instruction gained before a painting trip will obviously be an advantage. For example, life drawing classes can be a tremendous help in learning about proportions and other aspects of the figure, while a basic knowledge of anatomy is also useful. Even when people are wrapped up in a lot of clothes or are just a few blobs in the distance you will find that you can draw and paint them more convincingly if you have a general understanding of the underlying shapes and forms involved, how the limbs work, and their relative proportions. And such knowledge is all the more important when you want to work quickly and economically, perhaps incorporating figures into a painting on the spur of the moment.

Carry a small, pocket sketchbook so that you can make quick figure studies wherever there is an opportunity. This is a good way to build confidence and skill. Observe figures wherever you go, whether at airports, on trains or on the beach, and get into the habit of sketching anyone and everyone who looks interesting. Aim to capture their gestures and sense of movement, concentrating on the overall rhythms of the body rather than detail. You may have only a few minutes in which to make the sketch, so keep to a series of loose marks to suggest angles, movement and stance. When I'm on the move I sketch in pencil or pen, but when there is a little more time and space I work directly with watercolour, as with the study of *Mr Fooney* (below left), who was prepared to pose for a few minutes while waiting to take his next boat party up the Nile.

As well as helping you gain experience and confidence, the sketchbook studies will provide you with a very useful source of reference when you want to add some figures to a painting, either on location or in the studio. For watercolour sketches I work on separate sheets of paper, with a number of colour washes ready mixed for the flesh and clothes. I look carefully at the figure and then, concentrating on the basic shapes, I block in the flesh tones with simple strokes of colour, repeating this process for the clothes. As illustrated in *Les Tresses* (pages 92–93), my aim is to express the figures as economically as possible. Tight painting or

Below: **Mr Fooney, Aswan, Egypt** *23 × 35 cm (9 × 13¹/₄ in). Defining the head and limbs with a dark skin colour first, I established the poses and then added the clothing and background.*

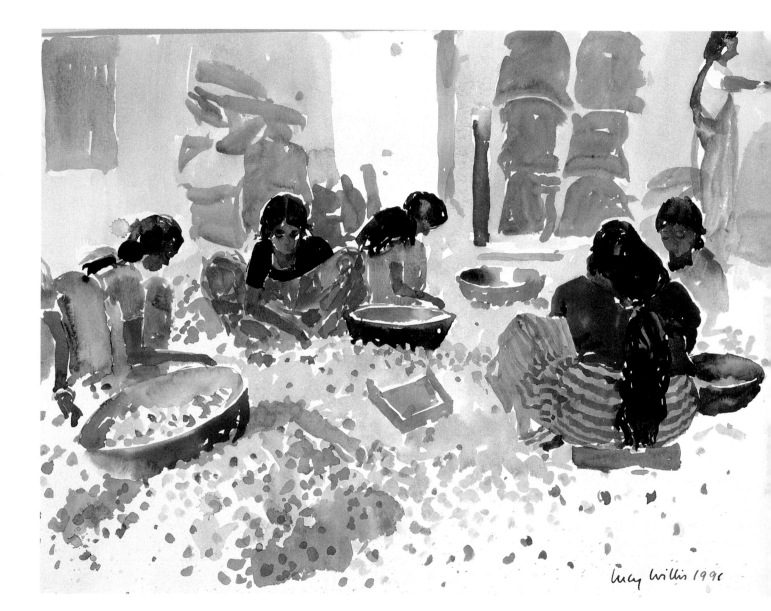

Lucy Willis 1996

too much detail results in figures that look rather wooden and lifeless and that jump out obtrusively from their surroundings if the rest of the picture has been handled in a more relaxed and confident way.

Often figures are moving and so may not be in view for very long. In this situation, I spend a few moments studying the figure and then, with the general shape fixed in my mind's eye, I can work in a very focused

Above: **Sorting Nutmegs, Cochin, India** *25 × 38 cm (10 × 15 in). Attracted by the scent of spices I found this group of women working in a hot and dusty room. They welcomed me in and plied me with cups of sweet tea as I painted in their midst.*

lucy willis 1996

head when the pose is shifted but going back to the first if the pose is resumed.

Alternatively there may be occasions when you can persuade someone at the location where you have stopped to paint, or at your hotel, to pose for you in a more formal way. This was the case with *Beautiful Accountant, Zanzibar* (below). She was the accountant at the hotel where I was staying with a group of other painters and she kindly agreed to sit for us. With this type of portrait, just like the figure sketches, I start by painting in the flesh tones, although obviously there is more initial planning of the proportions and features. Capturing a likeness very much depends on positioning the features

lucy willis 1995

Above: **Egyptian Grandmother, Aswan** *38 × 25 cm (15 × 10 in). This woman's grandchildren invited me in for tea and, struck by her imposing presence, I asked if she would sit for me there and then, which she was happy to do.*

Right: **Beautiful Accountant, Zanzibar** *38 × 25 cm (15 × 10 in). Zanzibar is a melting pot of cultures and it is fascinating to study the features of the different races that have settled there.*

and quick way. In contrast, with closer portrait studies, like those for *Bhaijibhai, Madhya Pradesh* (page 93), there is usually more time to analyse tones and details. However, as here, the subject may be engaged in conversation and move the head to slightly different positions. So the best approach is to work on a sequence of studies on the same sheet, starting a new

correctly and if possible without too much alteration or reworking. Otherwise the freshness of the painting is lost.

Figures in a Composition

When you are painting a street scene, landscape or interior and you want to include figures then it is essential to plan ahead so that you reserve the necessary spaces for them. You may decide to indicate the position of the figures in a very loose way, with a few pencil lines, right at the beginning, or you may hope to catch a suitable figure that will walk into your scene at roughly the right moment! In fact, figures can be added over areas that have already been painted, by wetting and lifting out the colour or by overlaying them on to

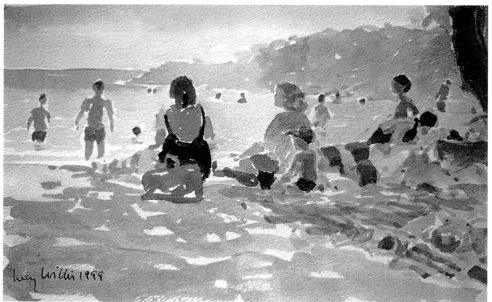

Above: **Shepherds Talking, Elephant Island, Egypt**
25 × 38 cm (10 × 15 in). Although they didn't stay for long, the sheep added a certain excitement when they arrived in the middle of this quiet scene.

Left: **Greeks on the Beach, Cyclades, Greece** *22 × 35 cm (8¹/₂ × 13¹/₄ in). A man who had been watching me work took this little painting to show his wife, at which point the wind whisked it from his hand into the sea. I believe it gained an added subtlety as a result!*

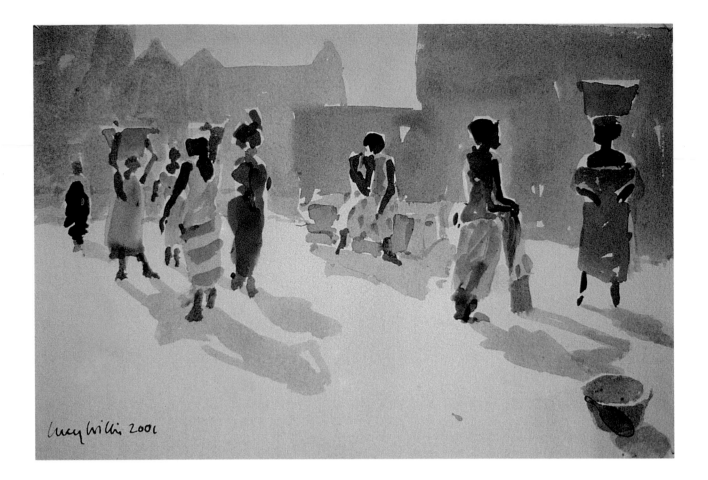

Above: **Women of Senegal, West Africa** 22 × 35 cm (8¹/₂ × 13¹/₄ in). I dotted in the briefest of colours as women came and went in the street, only working in more substance and background when I got home.

the background, but this is rarely as satisfactory as planning to incorporate them in the picture from the start.

An important point to remember when working on a composition that includes figures is to keep everything in the same 'language'. If they are not painted in the same style as the rest of the picture the figures will look incongruous and will tend to detract from the overall unity of the picture. Another point to watch is the proportions of figures in different parts of

the painting. Be aware of your own eye level to help you judge the size and position of the figures and capitalize on the fact that tiny, distant figures can help create a sense of space, such as those in *The Boujeloud Gate* (pages 102 and 103). Note any cast shadows, which can help to show figures as being anchored to the ground rather than floating in space, but take care to ensure they fall in the same direction as any other shadows in the picture (see *Women of Senegal*, above).

Chapter 3
Painting at Home

'I only started to produce something reasonable from my trip to Africa when I had begun to forget the little details and only remembered the striking and poetic side in my pictures.'

Henri Matisse, from his diary 20 years after visiting Morocco in 1912

Although the aim of a painting trip is to do as much work as possible from observation, it isn't essential to finish every picture on the spot. Time and circumstances will play a part in determining the amount of work that can be achieved, and the scale and complexity of the subject matter will also have a bearing on whether or not you are able to complete a painting while you are away.

Finished or not, there are advantages in having another look at every piece of work once you are home, to judge its success and decide if further work is necessary. There are various ways that paintings can be resolved and improved.

Soon after your return, while your experiences are still fresh in your mind, is also a good time to start new paintings based on what you have seen. These can be prompted by sketches, photographs and mementos or simply the memories and impressions that remain. You will find your travels inspiring and feeding into your work for months and even years to come.

Previous page:
Remembering Bhuj, Gujarat, India *58 × 42 cm (22¹/₄ × 16¹/₂ in).*

Right: **The Blue Fountain, Morocco** *42 × 48 cm (16¹/₂ × 19 in). Although I spent two morning sessions on this painting, returning to the courtyard only when the light was the same, there was still a certain amount to be resolved when I got home in order to pull the picture together: detail, perspective and tonal balance.*

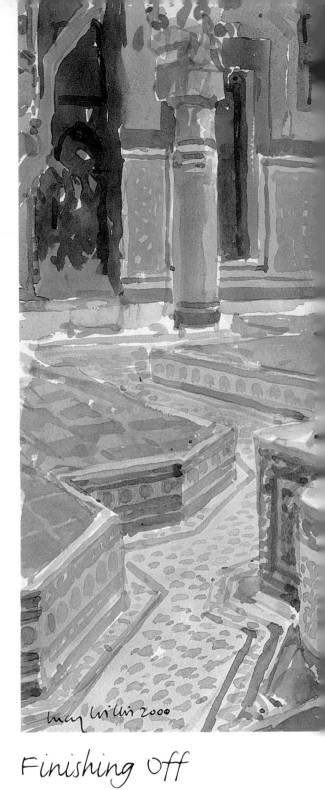

Finishing Off

I used to finish most of my paintings on location. However, now I find that a more efficient way of working on my travels is to spend the morning session on one subject

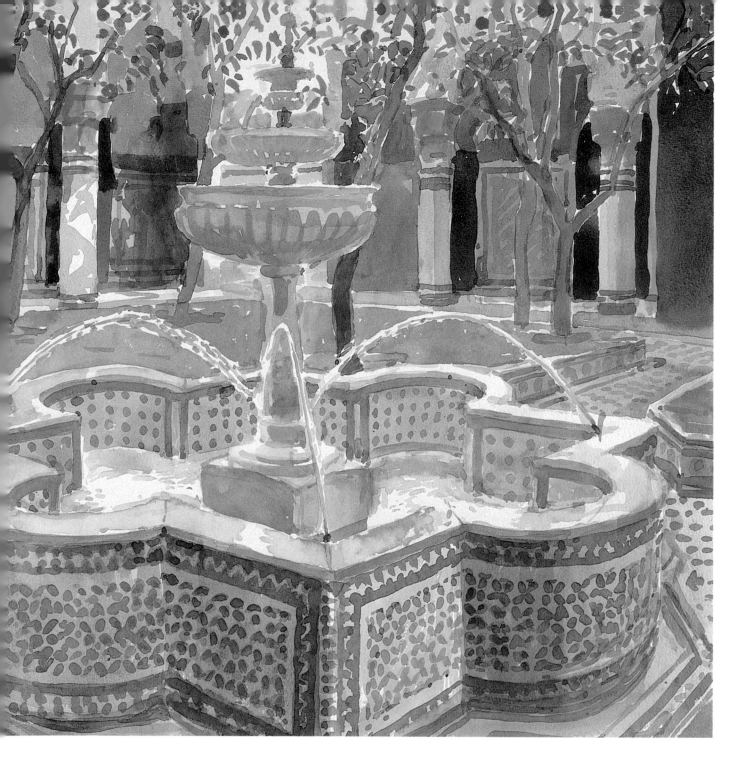

and then, later in the day (depending on the heat, rain and so on) I start a new painting. For a large, detailed subject I may need to return to the site at the same time the following day, but generally, once I have completed at least the essentials of the composition, tone and colour, I can leave any remaining work until I'm back in the studio. Occasionally I take a photograph to help me recall the scene, but usually I think it is best to try to memorize all the information I require.

This approach is more efficient because it enables me to make more paintings on location and therefore gain far greater value from my travel experiences. When I arrive home I look at all my paintings calmly and thoughtfully. I separate them into different groups. There are those that I consider finished, those that are almost complete but just need a little attention, and those that

are more problematic. There will also be some paintings in which I have deliberately left the sky to do later, or where there is a repetitive pattern or some other area or aspect that I need to complete. Such decisions were taken on location either to save time or because I felt that the particular approach or technique required would be better achieved in the studio.

The amount of further work undertaken on any picture has to be carefully judged, for there is always the danger of adding too much and consequently spoiling the freshness and impact of the painting. However, you may find that you have a few paintings that would benefit from a little more interest in their content – perhaps by including figures or strengthening the shadows. And there may be others in which you need to check and adjust the perspective or slightly alter the composition. When I had another look at *The Blue Fountain* (pages 100–101), for example, I made an elaborate check on the perspective, which resulted in some minor alterations, and I also completed the patterned tile area, which I had left unfinished on location.

If time is limited on location then it is best to concentrate on the main point of interest – the object or quality that attracted you to the scene and inspired you to paint it. The lights and darks are also important, but you could leave some of the

*Below and opposite page : **The Boujeloud Gate, Fes, Morocco** 42 × 30 cm (16¹/₂ × 12 in). Many months after painting this study (below) on an overcast day, I decided to add overlaid shadows to create an impression of evening sun (opposite page).*

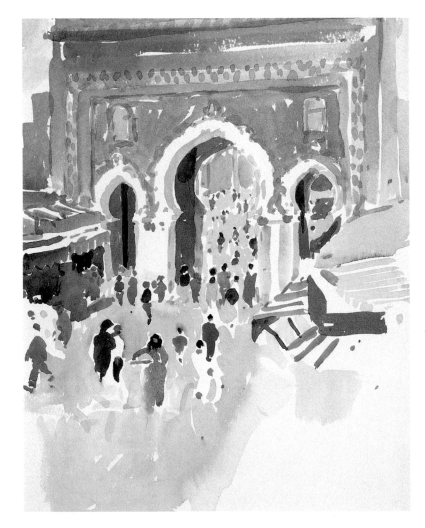

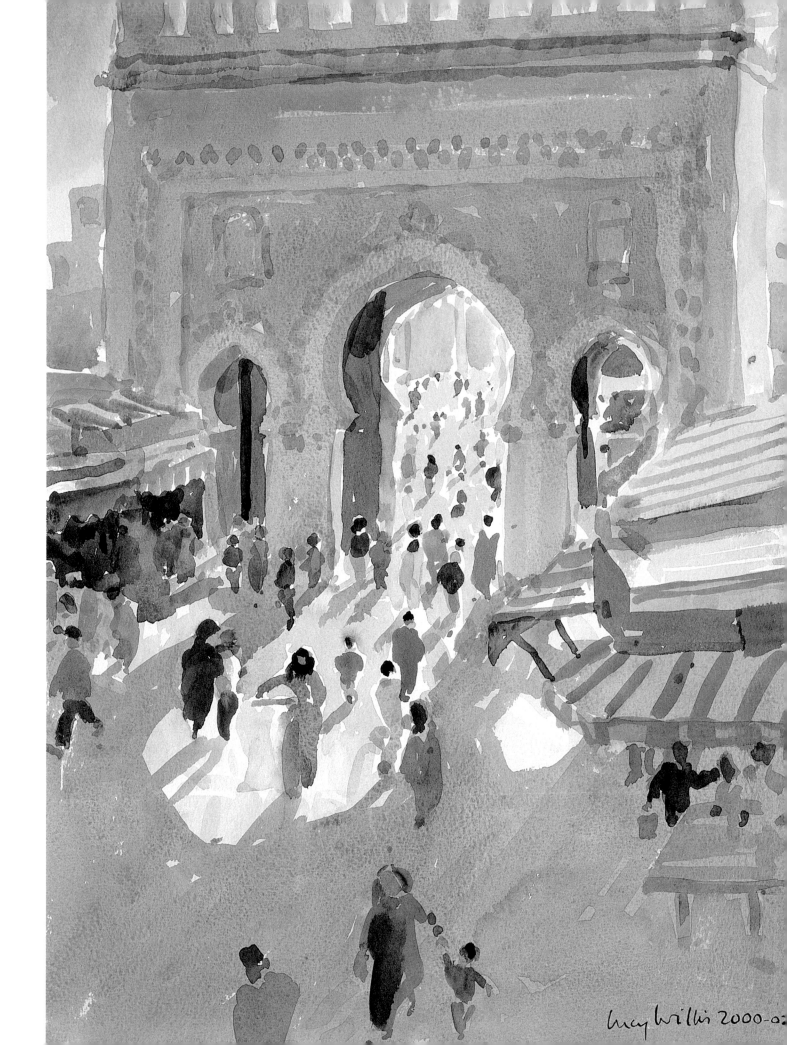

Lucy Willis 2000-0

secondary areas, such as the foreground, until you return home. Naturally, any additions that are made to the painting must fit in with what is already there. Try to recapture in your mind what it felt like to be at the scene and match the choice of colours and techniques to those already used in the painting.

This is particularly important when adding a sky. As I have explained, I often leave the sky when I am painting on location because I prefer not to paint buildings, trees and other shapes over the sky wash, as this can significantly affect the freshness and clarity of these shapes.

Adding the sky in the studio means that I can use clean water and so create fresh, translucent washes, and it also gives me the freedom to make changes to the composition if I wish – to add more trees, for example. But whatever I decide I am careful to relate the sky to the rest of the subject, and I try to recall the actual sky that I observed at the time.

Details and Alterations

There may be some paintings in which you have left gaps and others that, when reviewed at home, seem in need of something extra to make them work

Below: **Women Washing, Bhuj, India** *42 × 58 cm (16¹/₂ × 22¹/₄ in). To improve the composition of this painting I cut a strip, consisting of mainly wall and sky, from the top, turned the paper over and taped it to the bottom. Although you can see the join I don't think it matters too much and it was a necessary adjustment to balance the composition.*

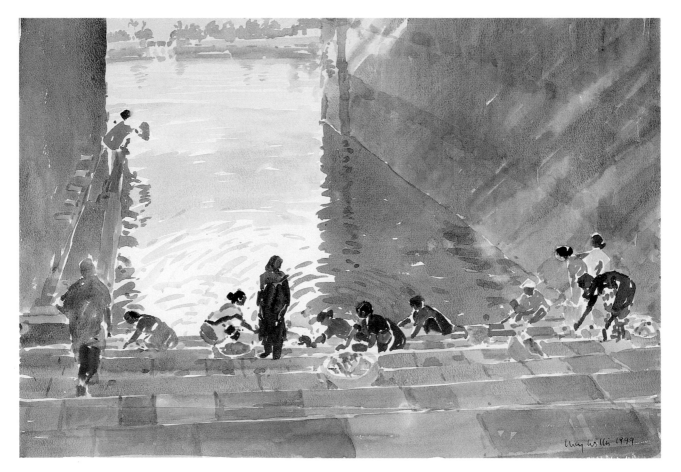

effectively. With discretion, shapes and details can be added to these paintings, either by painting over what is already there or by lifting out colour (see below) and reworking an area. However, these are techniques that should be used sparingly. Attempting major alterations of this kind in watercolour is always a high-risk strategy.

The danger with superimposed washes is that the colours can become opaque or muddy. But you can add or strengthen shadows quite easily, as I have done in *The Boujeloud Gate* (pages 102 and 103). In a similar way – with light touches of colour – you can indicate distant figures or introduce other simple shapes that will create interest. Conversely, you may decide to paint over figures or details that haven't worked.

In *Indian Goats* (page 106) I added the goats later, in the studio. Here, I was painting the scene when a herd of goats passed by, stopping to graze for a few minutes in front of me. I decided that it would be good to include some of these in the painting, but as they were constantly moving I thought it would be better to do this in the peace and quiet of the studio, where I could take more time over the positioning and painting of them. So I took some photographs to use as a reference later, and left the foreground unfinished so that I could add the goats where I wanted them. In watercolour it is always easier to make things darker than lighter, but for the white goat in this painting I lifted out the original colour and then enhanced the white effect by darkening the area around it. Lifting out is not a technique that I often use but it can be helpful now and again for making small corrections or when, in reconsidering a painting, you want to introduce a light shape in an area that has already been painted.

Lifting out works best on well-sized heavy-quality paper. Wet the area with a brush or sponge dipped in clean water and then use a dry brush, sponge or some tissue paper to soak up the paint. Let the paper dry thoroughly before repainting. Bear in mind, however, that techniques such as this usually bruise or damage the surface of the paper to some extent and that, inevitably, a certain amount of pigment will have stained the fibres of the paper, so it is unlikely that you will retrieve the original fresh whiteness.

Joining and Cropping

More drastic measures to rescue a composition that you are not happy with include cropping or adding to it with an extra piece of the same type of paper, as I have done with *Women Washing* (left). In my haste to capture the figures before they dispersed I positioned them too low on the paper, leaving a huge expanse above. Later, I cut off the top 5 cm (2 in) and, turning the

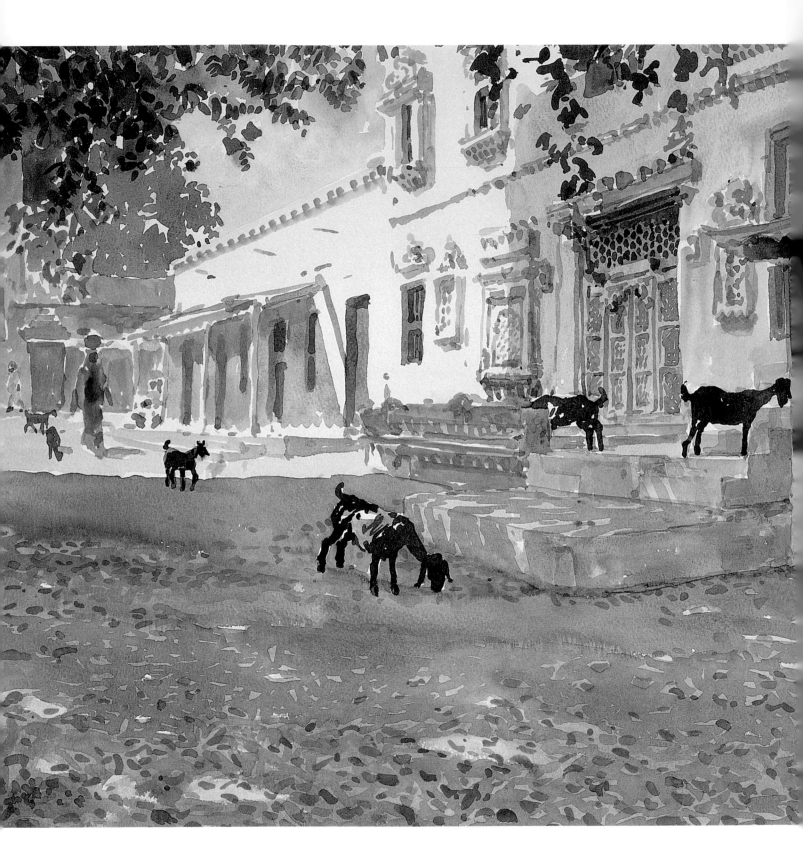

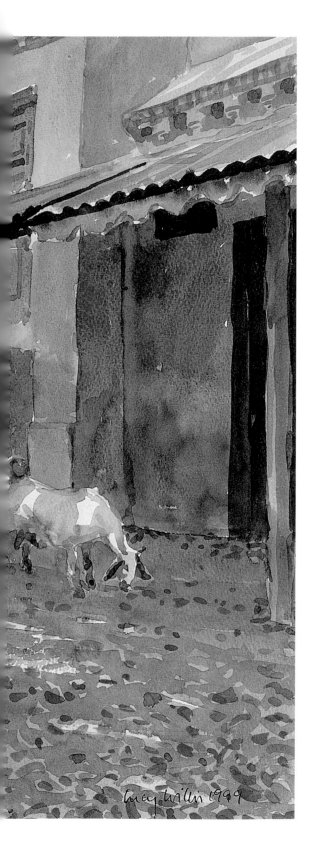

paper over, taped the strip of paper to the bottom of the painting, using archival-quality tape.

Of course, joining a fresh sheet of paper to an existing painting will only work if the join is neat and coincides with a strong line within the composition. Alternatively you can sometimes improve the composition by cropping – that is, by trimming the painting to a smaller size. However, it is always better to try to execute the idea as you envisage it, rather than rely on cropping the work later.

Working from sketches and Photographs

In addition to your watercolour paintings you will probably return home with many rough ideas, studies and notes in your sketchbook and also some photographs. These will help you recall the interesting places that you visited on your travels and they will make useful reference material to inspire further paintings. Now, if you wish, you can work on a much larger scale, developing your ideas with more care and consideration than the bustle of travelling will allow.

Left: **Indian Goats, Gujarat, India** *42 × 56 cm (16¹/₂ × 22 in). This was an occasion when I was glad I had my camera: the goats trotted into my view when I was halfway through the picture, so I snapped them with the idea of including them later. I left the foreground only vaguely suggested so I could work it up once the goats were added, with fallen leaves and shadows.*

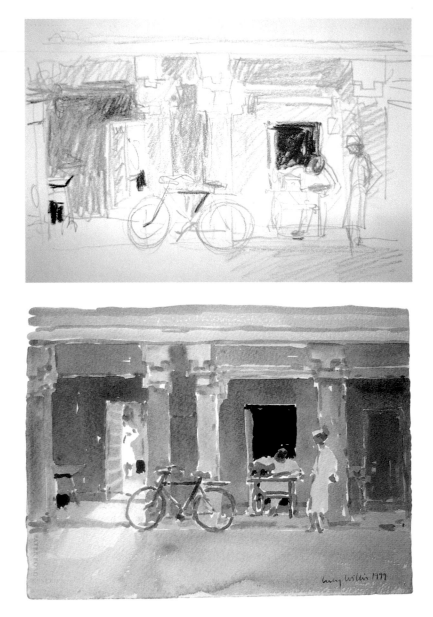

Top and above: **The Tailor of Bhuj, India** *15 × 21 cm (6 × 8¼ in). I made a quick sketch of this scene, from which I was later able to remind myself of the colours, tones and atmosphere enough to develop it into a small painting.*

watercolour that captures a particular sense of place. When I use sketches or photographs I try to remember what it was like to be at the scene, in front of the subject, and I adopt exactly the same process of working that I use when painting on location. However, I am very aware that there is an important difference between sketches and photographs. A sketch is likely to be quite limited in its information and consequently I must also rely on my memory of what I observed, whereas when referring to a photograph I will probably have more detail than I need and so will need to simplify what is there and select the elements that are most important for my purposes.

Using sketches

In my sketchbook I use a variety of sketching media, as explained on pages 40–42. Some of these drawings are made in coloured pencils and consequently, because all the colour reference is there, these are quite easy to translate into a more finished result in watercolour when I return home. *The Tailor of Bhuj* is an example of this. For other subjects I may have concentrated on a tonal sketch for the actual location study, jotting down one or two notes about the colours (see *Verdi Requiem*, opposite) or, because of the time constraints or particular circumstances, I may have decided that a linear drawing was the best

Whether you choose to paint from sketches or photographs, or perhaps a combination of the two, the aim should be the same – to create a fresh, interesting

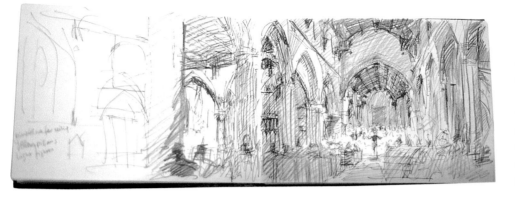

Left and below: **The Verdi Requiem, St. Mary's Church, Bridgwater, England** *42 × 58 cm (16¹/₂ × 22³/₄ in). I sat at the back of the dark church to make this sketch (left) and provided myself with enough information to make the larger watercolour in the studio (below).*

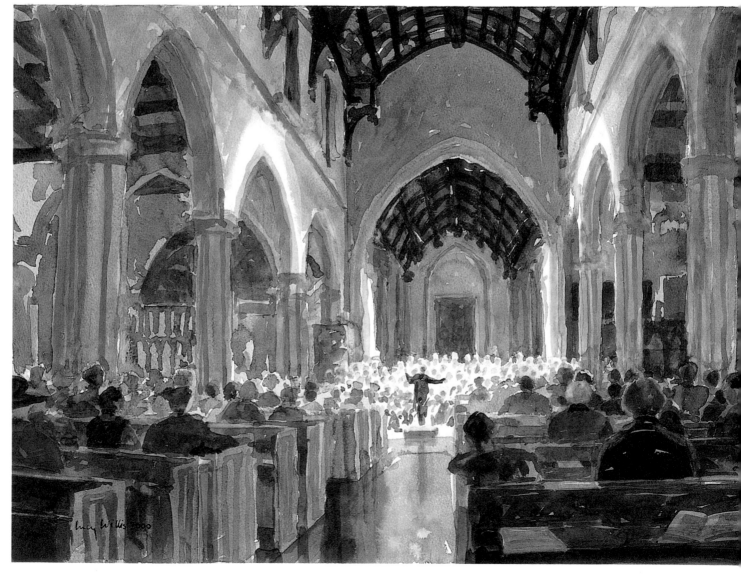

Opposite: **Sketch for Conversations, Greece**
15 × 21 cm (6 × 8¹/₄ in), black ballpoint pen.
I covered several pages during an afternoon on the beach, watching people standing and talking in the shallow water. Later I composed a series of watercolours at home using these figure studies, rearranging them into different groups.

Below: **Conversations, Greece**
22 × 30 cm (8¹/₂ × 12 in) watercolour.

approach, as in *Cairo Night* (page 117). Normally I rely on a single sketch supported by my memory of the subject, rather than making a sequence of studies and detailed notes. But at some locations, such as on a beach, I am tempted to sketch several different aspects or a variety of people, and occasionally I take a number of references of this kind and work them into a single watercolour painting, as was the case with *Conversations, Greece*, below.

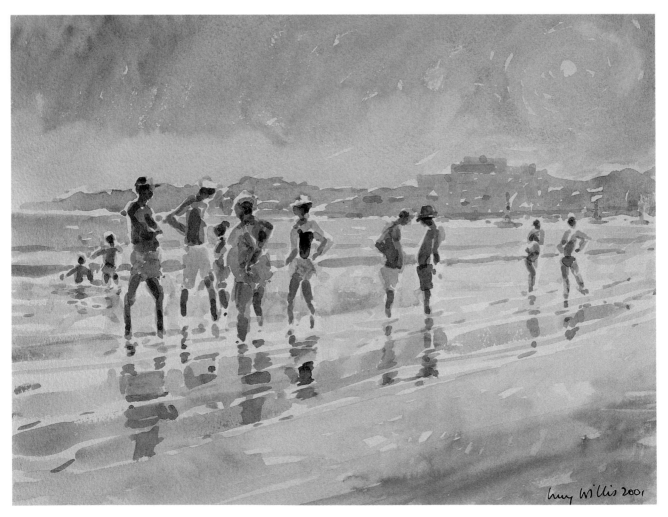

Reference Photographs

When using photographs there is always the temptation to copy detail and so produce a painting that is fussy and overworked – I've resisted using photographs in the past precisely for that reason. Now I am happier to work from photographs occasionally, since I have taught myself a method of doing it that reflects the way that I paint on the spot. I give myself the same time restriction as if I were painting on location and watch very carefully that I am not overworking the painting or diverging from my usual style.

My advice is to use your own photographs. If you took them it means that you once stood in front of the scene, impressed by what you saw, and therefore you should be able to recall that feeling and also the mood and atmosphere of the place. The other point to bear in mind about photographs is that they are not as truthful as we suppose them to be, especially with regard to perspective, distance, tone and colour. So, use them as a starting point and, as I do, try to generate the same sense of energy with the painting that you would experience if you were working directly from the subject. And remember that as an artist you have the power to select, exaggerate and interpret according to your own sensitivity for the subject. With *Remembering Bhuj* (page 99) I reproduced

the blue walls and doorway much as I saw them in the photograph, but decided to leave out a motorbike that was in view, and add figures inside the courtyard. These were entirely invented, although based on countless such sightings of vivid saris flitting in and out of view.

Squaring Up

There may be some individual photographs or sketches from your travels that are perfect ideas for watercolour paintings, so that you can take the composition as it stands and simply enlarge it on to a sheet of paper. I use two methods for enlarging: for architectural subjects and other paintings in which accurate shapes and proportions are

*Above left: **Bhuj, Gujurat, India**, photograph. My 1999 trip to Bhuj with a painting group was a particularly memorable and productive one, but two years later much of the old city was destroyed by a massive earthquake, along with thousands of people. My photographs and sketches from 1999 became all the more poignant after that event and I have started to use them for new paintings such as the one at the beginning of this chapter (page 99), using this photo with certain additions and omissions.*

an essential consideration I usually choose the squaring-up method, while for landscapes and more general scenes I adopt a freer approach, judging the position of things by eye and using my brush to measure and plot relative sizes.

Squaring up sounds rather mechanical and perhaps it implies that the resultant painting will be tight and confined in some way. It need not be. Once you have the skeleton of a drawing to work from you can develop the painting in your usual style, and for my part that means keeping it loose and fresh.

You needn't damage your sketch or photograph by drawing the grid of squares directly over it. Attach a sheet of clear acetate over it first and mark your squares on to it with a felt pen. Keep to a simple grid (perhaps four by six 2cm/1in squares) and then replicate this in pencil on the painting paper on a bigger scale (perhaps four by six 5cm/2in or 8cm/3in squares). Make the lines faint and broken so that you can easily rub them out afterwards. Then, referring to the original sketch or photograph, look at each square in turn and redraw the main outlines appropriately larger to fit the corresponding square on the paper. Once you have the essential shapes you can erase the grid lines. Later, when the painting is finished, you may want to rub out other pencil lines that show. This can be done carefully with a putty eraser. If, in the

process, you lift out some of the paint, you can simply strengthen those areas with a further wash of colour.

Exploring Other Media and Techniques

As well as painting in watercolour, you may be interested in other media and techniques. I also paint in oils and throughout my career I have devoted a lot of time to printmaking, especially etchings and monoprints. The ideas and experience gained in one medium can, I think, help with another. For example, my work in printmaking, with its concern for separating areas of colour and thinking in terms of negative spaces, has helped my watercolour technique. You can see this in the step-by-step demonstration watercolours on pages 51 and 85.

So you could choose to use some of the watercolours and drawings made on your travels as the inspiration for work in other media and techniques. If you do, keep in mind that each medium has its own qualities and strengths, which will obviously influence what can be achieved. Therefore, in a new interpretation of an idea, using a different medium or process, it is best to focus on the possibilities of that particular medium, rather than attempt to imitate what has already been done in the

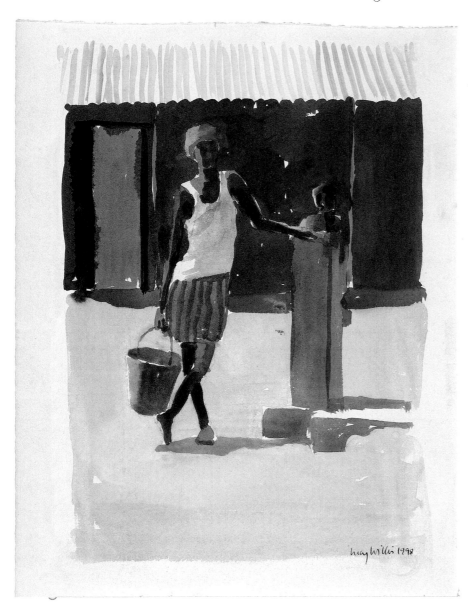

Left: **Fetching Water,
Senegal–Gambia Border, West
Africa** *40 × 32 cm
(15¹/₄ × 12¹/₂ in). Stopping briefly
for a passport check at a village
border post I took a photograph
of a figure with a bucket. I liked
the image so much that I used it
first as the basis of the
watercolour and later a series
monoprints.*

Opposite page: **Juhu Beach,
India.** *Pencil sketchbook studies.*

location watercolour or drawing. In *The
Picnic* (page 115), for example, which is an
oil painting, I was able to translate a
watercolour painted by the sea on to
canvas, working on a larger scale but
changing certain aspects when I felt it
helped the composition. And with *Temple
Elephant* I could make use of the analysis of
colour and tone that I did for the
watercolour (page 116) to help me with the
more limited colour separations that I
needed for the print (also page 116).

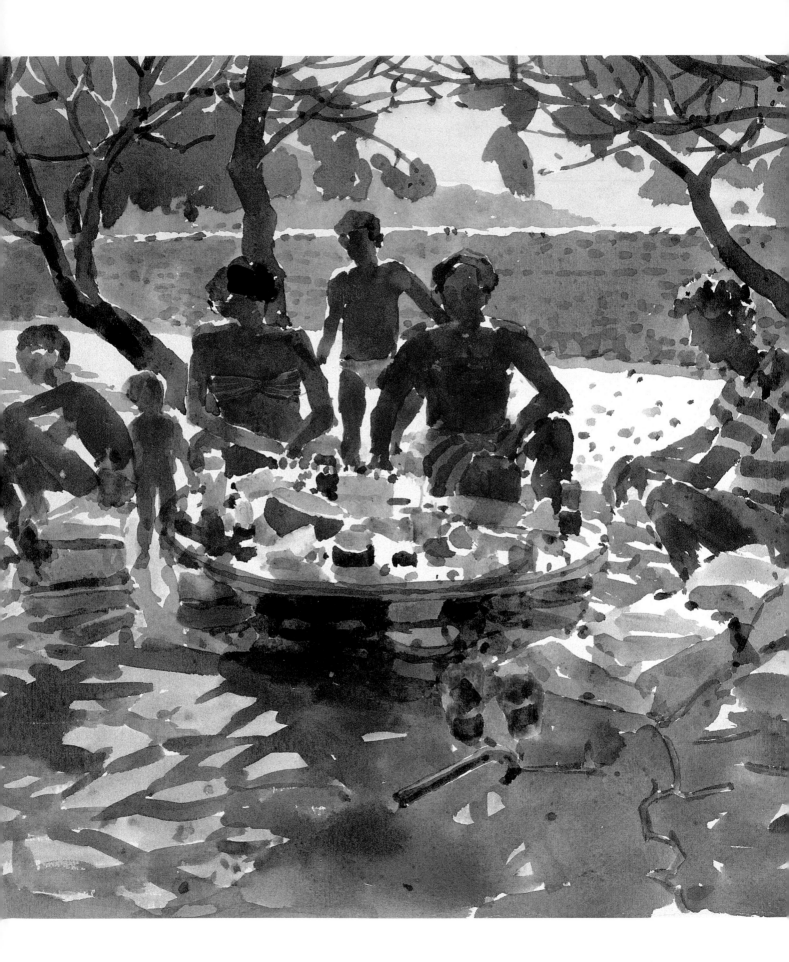

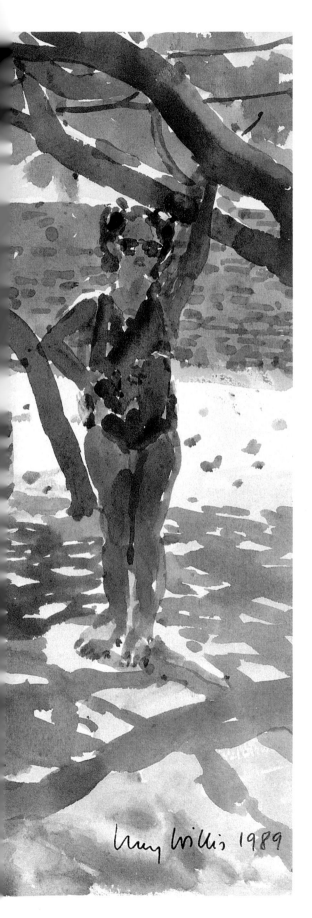

Lucy Willis 1989

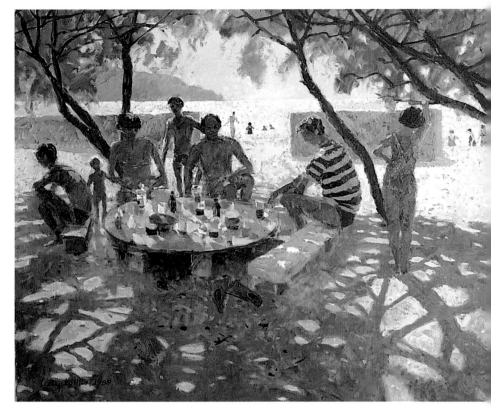

Left: **The Picnic, Syros, Greece**
32 × 43 cm (12⁵/₈ × 17 in).
I used this watercolour, painted
on a family holiday, as a study
for a large oil painting.

Above: **The Picnic, Greece**
76 × 92 cm (30 × 36 in), oil on
canvas.
Certain aspects which seemed to
work well enough in the water-
colour study needed a degree of
adjustment in the oil painting,
such as the wall behind the
figures. I decided to make
breaks in it to allow a view to
the sea beyond and turned the
little girl in pink to look the
other way.

Right: **Temple Elephant, Madurai, Southern India** *30 × 20 cm (12 × 8 in). Occasionally a watercolour image has the potential to translate into an original print. On returning to my studio I thought this, with simplification of the colour scheme, would work as a two-plate etching.*

Below right: **Temple Elephant, Madurai, Southern India** *49 × 34 cm (19¹/₄ × 13¹/₂ in), coloured etching.*

Opposite page top: **Cairo Night, Egypt** *56 × 89 cm (22 × 35 in). From a balcony in Cairo on a hot and busy night, with music playing and a festival atmosphere, I spent some time trying to impress this image on my mind. The next morning, when the scene was mundane once more, I made a little pencil diagram of the position of the buildings. With the help of the drawing but mainly relying on my memory, I painted this large watercolour in the studio, having mulled the image over for weeks. The lace of the curtains was suggested by drawing the pattern with a wax candle and then painting over it.*

Opposite page bottom: **The Tempest, Hestercombe, Somerset** *15 × 21 cm (6 × 8¹/₄ in), wax crayon and watercolour. During an outdoor theatre performance this image of stage-lit figures made a strong impression. The next day I jotted this reminder in a sketchbook and later developed it into a monoprint.*

Memory and Imagination

'It is much better to draw what you can't see any more but in your memory. It is a transformation in which imagination and memory work together. You only reproduce what struck you, that is to say the necessary.'

Edgar Degas, from *Memories of Degas* by George Jeanniot.

However diligent you are on your travels, there won't be time to sketch and paint every subject you come across. But sometimes the briefest note will do to remind you of a scene, and there will also be striking views and events that you hold in your memory. These can provide the starting points for paintings at home, and you can develop such ideas either by looking for suitable references in some of your other sketches and paintings or by relying on your imagination.

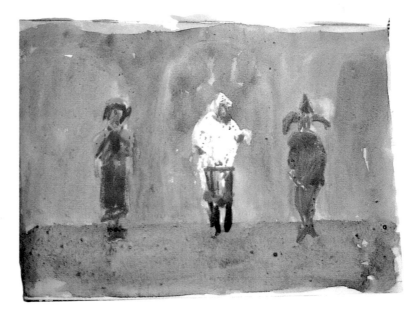

Visual Memory

A good visual memory is an advantage to most artists, especially when working in the studio from sketches and similar reference material made on the spot. If you are able to find a way of memorizing colours, tones, shapes, sizes and other aspects of a subject, this will provide useful supplementary information to whatever is conveyed in the sketch. Developing your visual memory takes time and practice, and the best way to

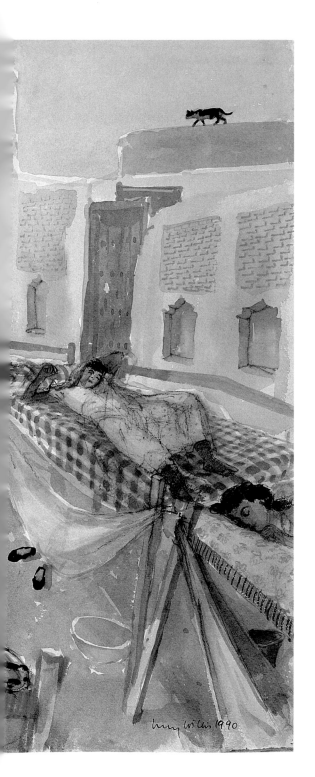

help train it is to observe and draw things as much as you can. In particular, try to master the art of the quick sketch: the ability to jot down in four or five minutes the salient structure and features of a subject.

When you are relying on very limited reference information for a painting, or working entirely from memory, you may find it helpful to start with a series of rough sketches as a way of organizing your thoughts into a coherent idea and composition. And you may want to practice drawing certain shapes before committing them to the watercolour paper.

For *Grey Dawn, Zabid* (left), which is another studio work, I used a combination of approaches. It includes a good deal of imagination, but I also worked from models. This painting is based on a very strong memory of waking up in a village in Yemen, surrounded by sleeping Yemeni women. I tried to remember the architecture, the way the beds were laid out, the particular quality of light, and so on. For the figures I asked various friends at home to dress in the appropriate clothes and then made drawings of them in a variety of sleeping poses that I thought would be useful for the final painting.

This is a technique worth noting. If you want to include some figures in one of your paintings and you do not have any reliable reference or the confidence to add them

Opposite page: **Grey Dawn, Zabid, Yemen** *67 × 101 cm (26¹/₂ × 39¹/₄ in). Travelling with my sister in Yemen, we found ourselves staying with a Yemeni family. At night all the women and children slept out in a courtyard for coolness, and this was my enduring memory of the early morning scene when I awoke. Back in England I asked friends to pose for me lying down in the appropriate clothes so I could get some ideas for the sleeping figures. I was so inspired by my experience of family life in Yemen that I carried on working on the theme for months.*

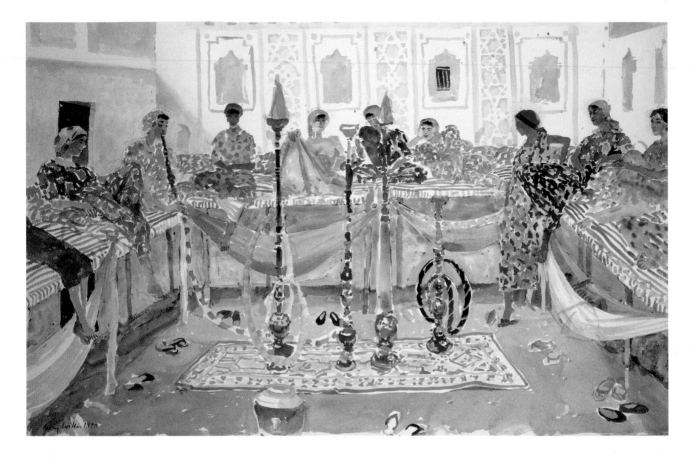

Above: **The Courtyard, Yemen**
*67 × 101 cm (26¼ × 39¼ in).
During our days in Zabid we
were taken to visit merry
groups of women at home and
unveiled, smoking tobacco and
chewing* khat. *I managed to do
some tiny coloured sketches
which helped when I came to
reconstruct the scene at home.*

Right: **Athens Market, Greece**
*50 × 64 cm (20 × 25 in), pen
and ink, watercolour.
Thinking of how Shakespeare's
characters might have worked,
I imagined this market, helped
by memories of Athens and
earlier watercolours of light
and shade in city streets.*

from imagination, then ask someone to model for you. Try a few sketches or simple watercolour studies until you have the pose and information that you need.

Using Your Imagination

The more you observe and work from life and from memory, the easier it becomes to create images entirely from imagination. For me this is particularly useful in terms of illustration, when I want to create a certain image but have little or no reference material. In 1987 I went to Greece with the idea of illustrating *A Midsummer Night's Dream*, which Shakespeare set in 'a wood outside Athens'. Having lived in a Greek village for three years I wanted to utilize my knowledge of the Greeks and their setting as the basis for the series. I painted a number of half-finished watercolours of my favourite places, leaving spaces for the characters, and later peopled them from my imagination, as

can be seen in the two stages of *Village House, Greece* (below). In another of the illustrations, *Athens Market* (below left), I invented the scene by recalling my many visits to the flea market in Athens.

Left and below: **Village House, Greece from A Midsummer Night's Dream** *50 × 64 cm (20 × 25 in). Back in my familiar village in Greece I found locations to paint, into which I could later place the imaginary characters. To complete the illustration I added the figures in pen and ink, basing them on Greek people I have known, and then I completed the left-hand wall around them.*

Likewise my travels to India and my numerous drawings of people there helped me when I needed to illustrate an article about dam building in India (see *The Indian Supreme Court*, above). Also, painting the English landscape for years meant that I could invent a setting for *Fly Fishing* (left). The starting point for this was a request to make a collage using a collection of exotic prints of fish and I decided to set them into a large watercolour river scene. The figure was drawn by trying hard to imagine how a despondent fisherman would sit, making a few preliminary sketches to work out his expression and demeanour, and then incorporating him into the picture.

Left: **Fly Fishing**
61 × 105 cm (24 × 41¹/₂ in), watercolour with collage, pen and ink.
Calling on my experience of painting trees and water in England, I was able to invent a damp and misty scene into which I could incorporate the fish, cutting and pasting them in a way that looked as if they were weaving through the trees.

Above: **The Indian Supreme Court** *56 × 89 cm (22 × 35 in). Having done a lot of drawing and painting of figures from life in India, it came quite easily to me to conjure this imaginary character out of thin air in order to illustrate a point about the controversial Narmada Dam Project.*

Objects and Mementos

Few people can resist the fascination of shops and markets in foreign countries. They provide a special insight into the local society and usually offer a wealth of artefacts and curiosities unique to that particular place. It is always tempting to bring a few things back. My preference is for fabric, pottery and any unusual cooking or gardening utensils that are not too difficult to pack. All these things make ideal subjects for still-life compositions, and for months and years after I have visited a place I can rekindle the experience by painting them at home.

*Left : **Yellow Moroccan Bowls** 48 × 35 cm (19 × 13¼ in). Long after the immediate memories of a trip have faded, you can continue to evoke the experience by painting the things you have brought back. Whether these are fabrics or local artefacts like pottery, they can provide endless material for still lives.*

*Above: **Granada Pomegranate Bowls** 29 × 30 cm (11¼ × 12 in). I bought these bowls in Spain because I loved the strange colour of the glaze. They have since become one of my favourite things to paint at home.*

Index

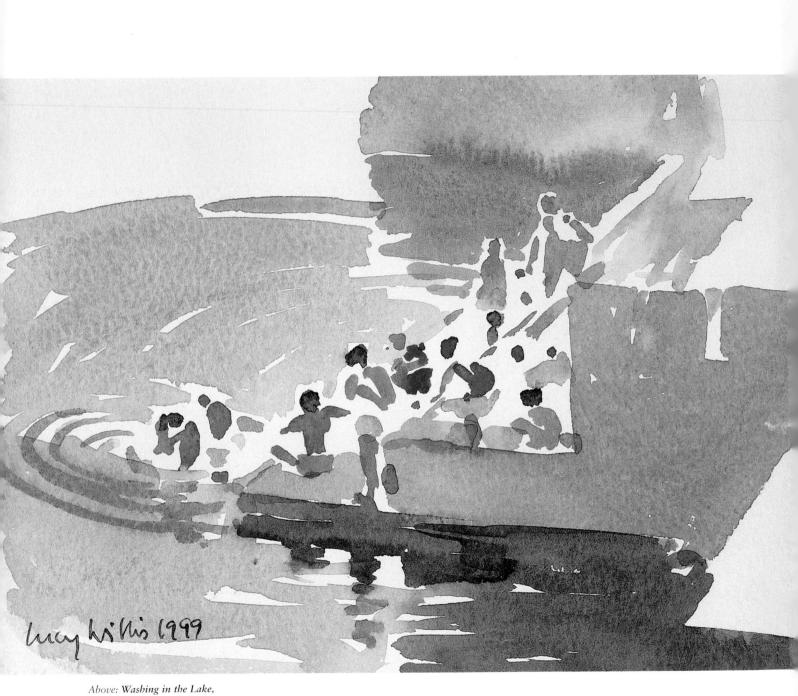

Lucy Willis 1999

Above: **Washing in the Lake,**
Udaipur *14 × 19 cm*
(5¹/₂ × 7¹/₂ in).